DESIGNINGWITHLIGHT

DESIGNING

Franz Werner

WITH**LIGHT**

IMAGE MAKING FOR PRINT + VIDEO

Self published by Franz Werner

© 2018 Franz Werner

All rights reserved

Printed and bound in Italy

First Edition

Contents

Introduction

This book demonstrates how the photographic image has secured a place for itself as an integral medium of graphic design. As early as 1919, the Russian Constructivists and the Dadaists used photography as part of their creative process. At the Bauhaus in Weimar, it was László Moholy-Nagy who pioneered the marriage of type and image.

My work and my teaching in the area of type and image show an unequivocal association with the Bauhaus, though this manifestation was not intentional. My photographic work occasionally deals with socioeconomic or political themes, but not to the extent of the Dada or the Constructivist movements.

The difference between my work and that of a conventional photographer is the aesthetic criteria applied to it. It is not my intent to criticize nor to minimize traditional photography but to clarify my pedagogy in the context of this medium.

The profession of graphic design in the Western Hemisphere has strong ties with its writing system, the Latin alphabet. As I wrote in *Design School of Wisdom*, by "Looking at the development of our writing system since the hieroglyphs, one can witness a gradual simplification of form. It is this simplifying, reducing and abstracting of information, which is one of the main criteria in the language of graphic design." The influence of this systemization and/or simplification is most notable when the art director of a project is a graphic designer using photography.

Ultimately, the essence of any writing system has its roots in sharing knowledge, expressing emotions, and recording history: I.J. Gelb describes writing as a "system of human intercommunication by means of conventional, visible marks."

In the past, I have had interesting discussions with photographers about the role of the photographer versus that of the graphic designer in publication or exhibition projects. We agreed that in the event of a collaborative project, one of the most important points to decide on is the cropping, bleeding, scaling, and placement of the image. Obviously the destination of the end product (magazine, book, postage stamp, exhibition, billboard, packaging, screen, etc.) will determine the way the image is treated according to established criteria and/or conventions. One of the most important design challenges is that of scale versus resolution. A different set of criteria is applied to an image printed on a billboard than one that is displayed on a tiny cell phone.

The work presented in this book is a compilation of student work. All of the student work was created in the following classes: Photo/Video Graphics, Form and Communication, Type and Image in Motion, and Music Video.

Werner, Franz. *Design School Wisdom: Make First, Stay Awake, and Other Essential Lessons for Work and Life*, edited by Brooke Johnson and Jennifer Tolo Pierce. Chronicle Books 2014. (first published February 25, 2014)

Gelb, I.J.. *A Study of Writing*. o.i.uchicago.edu; INTERNET. University of Chicago: Chicago, Illinois 1962: 12.

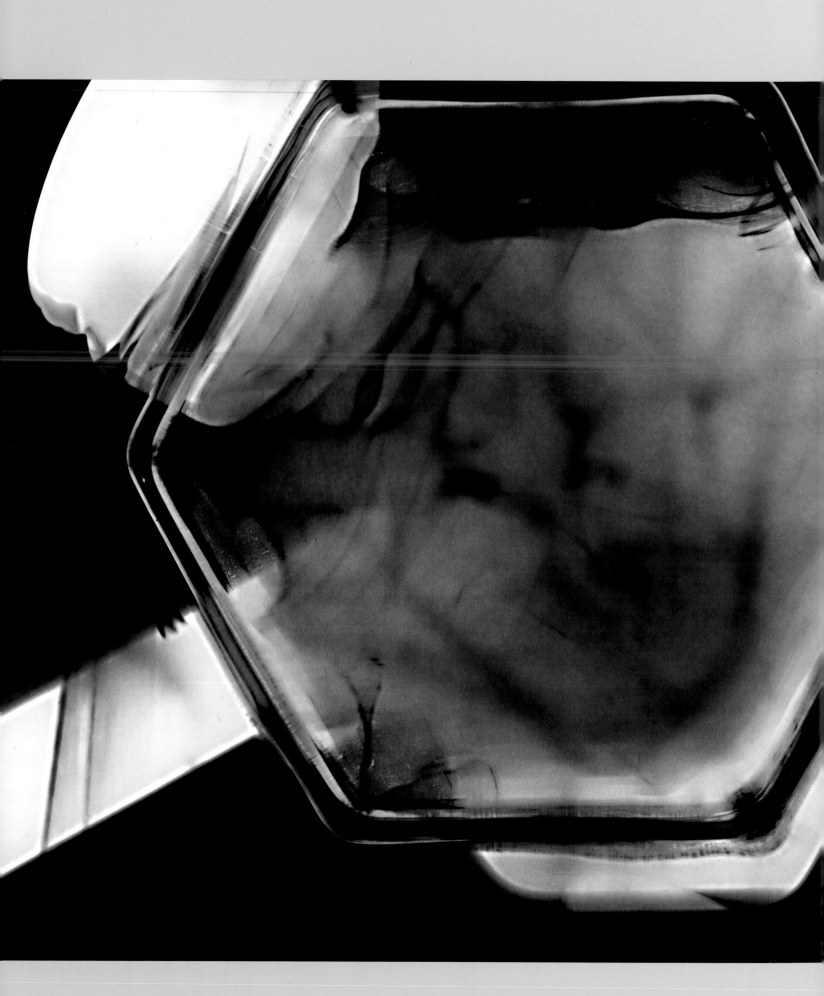

THE PHOTOGRAM

1

Although it gained tremendous popularity in the twentieth century through the work of Man Ray and László Moholy-Nagy, the photogram has an obscure early history. Probably developed before photography proper, this technique has been described by many names; often it was simply called "lens-less photography." Ironically, its nineteenth century pioneers saw little artistic potential in the medium. To them, it seemed primitive; it did not allow sufficient artistic control. Apart from its use in the "cliché verre" technique of the 1850s, in which light was projected onto photo paper through etchings in black glass, the photogram was largely relegated to scientific use. In the early twentieth century, however, the technique was embraced by the Dada movement as representing and provoking the notion of anti-art and anti-photography. Seen as a liberation from traditional photography, the photogram continued to play a significant role in Surrealist and Constructivist work.

IN MY COURSE:
The photogram, although achieved through a very simple process, possesses a rich, symbolic quality. Objects placed on photo paper and exposed to light become dimensionless, abstract, and unfamiliar. Artists like Moholy-Nagy, Man Ray, Raoul Hausmann, and Meret Oppenheim realized the potential of this effect in graphic design. In his *Foto Qualität*, for instance, Moholy-Nagy sensitively combines letter forms and photograms to a powerful effect.

The thoughtful designer will understand the potentials and the limitations of the photogram. Some objects—an apple, for instance—will lose their identity through the process, while others—like a door key or bird's feather—are already so graphic that further reduction becomes redundant. The designer will notice, too, the potential for visual discourse between photogram and photograph.

For example, juxtaposing a photogram of an oak leaf with a photograph of the tree serves to dramatically emphasize the abstract qualities of the photogram and radically alters the viewer's perception of the tree.

The Process

A. A branch of leaves is placed on top of the emulsion of the photo paper

B. The photo paper is exposed to light for approximately 5 sec +− at an f-stop setting of 5.8 +−

C. The exposed photo paper is ready to be developed

D. The exposed photo paper is submerged in the developer for approximately 60 sec

E. The developed photo paper is submerged in the stop bath for 30 sec

F. The photo paper is submerged in the fixer solution for 120 sec

G. Rinse the print in running water for 20 min and let dry

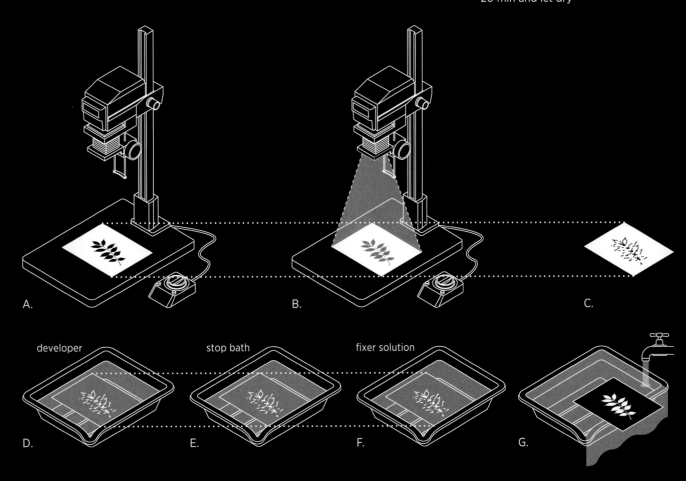

developer

stop bath

fixer solution

A. B. C.
D. E. F. G.

Materials and equipment

OPPOSITE
Max Ackerman
Form and Communication, 2007

THE FOLLOWING MATERIALS ARE SUGGESTED:

- photo paper (of any grade)
- photo chemicals: developer, stop, and fix
- photogram objects
- running water

A FULLY EQUIPPED DARKROOM IS IDEAL BUT NOT NECESSARY:

- photo paper must be handled only in a darkroom with red or yellow lights
- light sources to expose the photo paper can vary from a flashlight to a lit match
- chemicals must be carefully handled according to the product description and disposed of properly

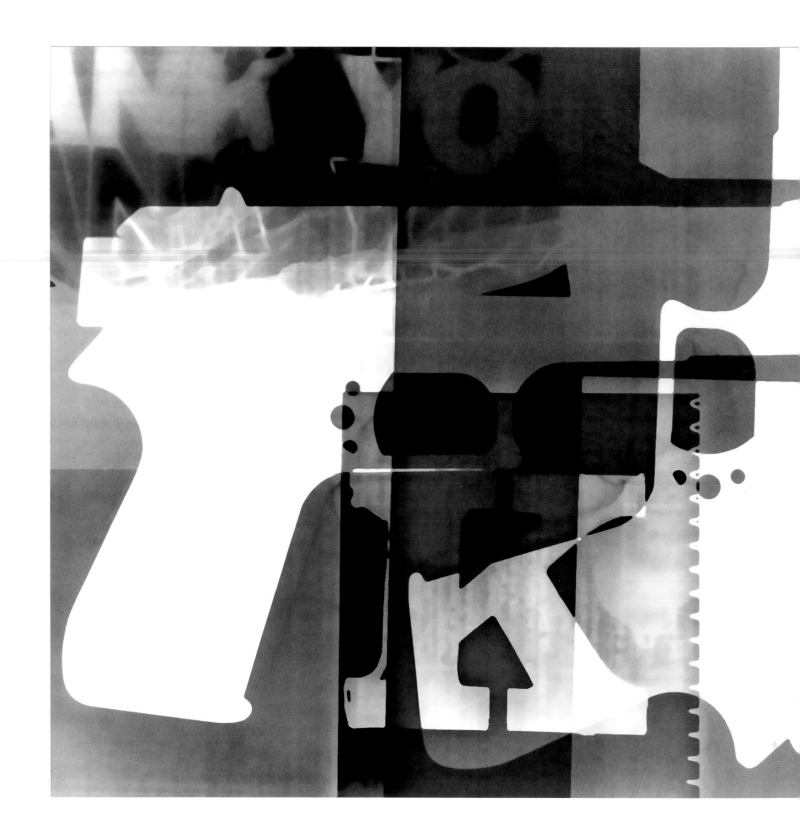

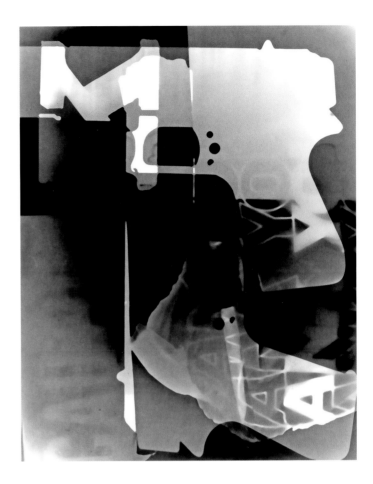

Ben Scott
Form and Communication, 2004

BEN SCOTT

I was curious about the photogram's ability to reveal x-ray-like images. It is hard for me to describe my intent because I feel that most of my designs are unintentional. If I was forced to reason with the idea, I would say that the handgun and its concealment were of interest to me. The plastic bag is an everyday object that is so commonly seen. The gun is not. I was hiding one within the other. I do not feel that my photograms were intended for anyone but me. They were simply expressions of how I felt. The process for making this photogram could have been described with as much depth and density as a scientific thesis on organic chemistry. For me process is and always will be only secondary to the end result. Design can be planned, thematic, and strategically based but the result all too often is something that is purely hideous by visual standards. Bad design is defended by an over indulgence in describing the approach or process that was used along the way. For me this is a crutch. Too many artists and designers lean on this idea of process far too frequently. It becomes their art. Their rubric for defining good and bad are founded by how you got to where you are.

For me, you got there and that is what matters, look at what is in front of you and not behind. These photograms are not for use in some corporate typogram or logo if they need to be I would do that. The photogram is the base level of abstraction in visualizing something. It is not a matter of how you did it or what you intended to say rather that your statement is absorbed.

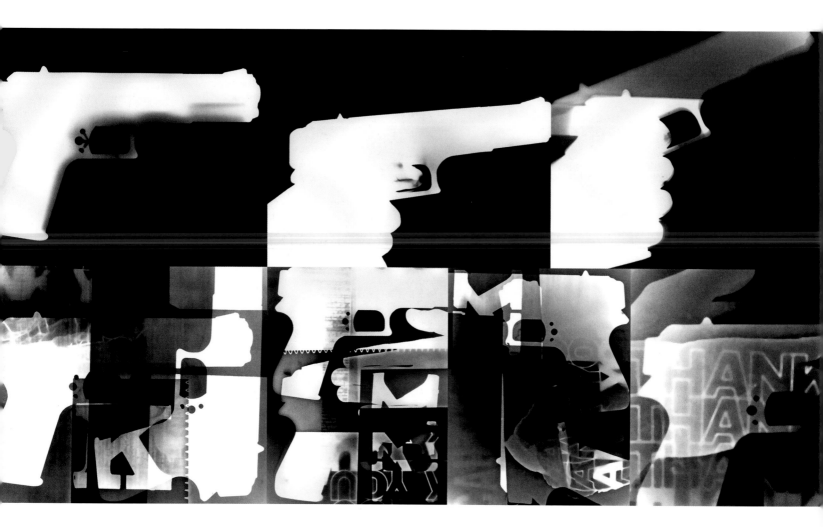

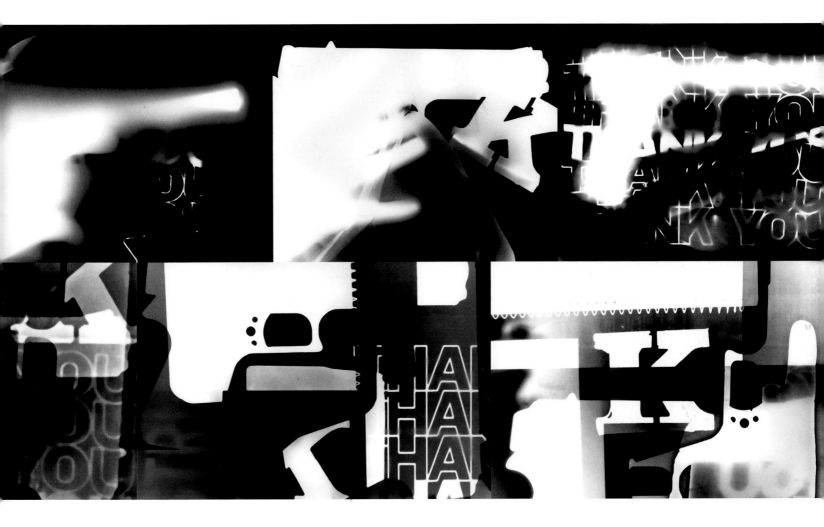

Ben's approach is described as a loose collage technique,
in which the various objects and materials are
arranged purposefully on top of the photo paper and
directly under the enlarger.

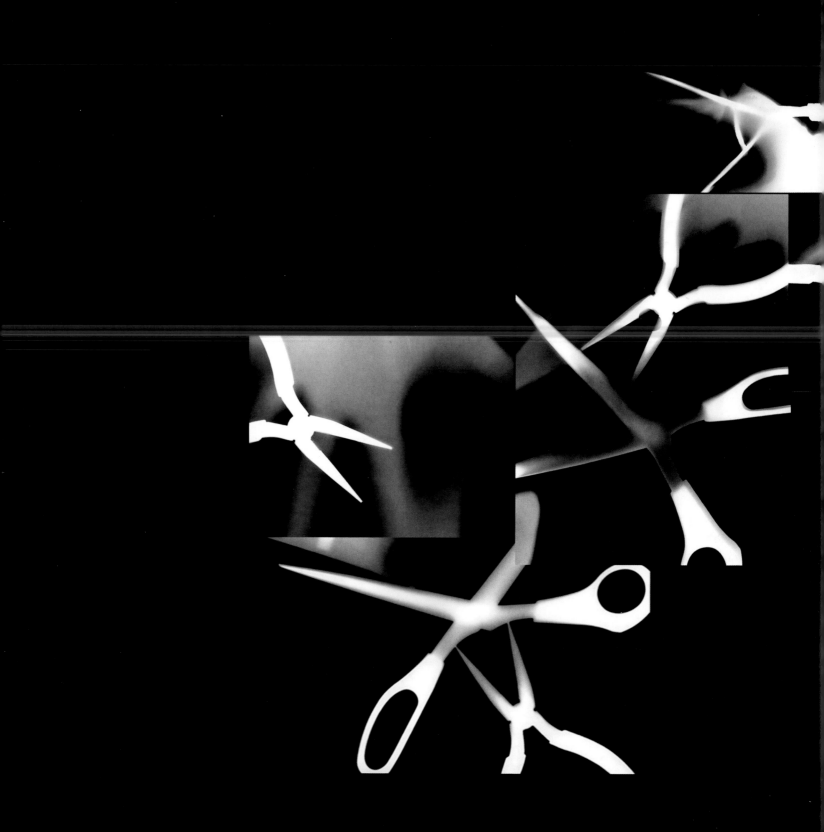

The photogram presents to the viewer the perfect opportunity
to focus on the form of the object(s) it documents, without being
distracted by color or other decorative elements.

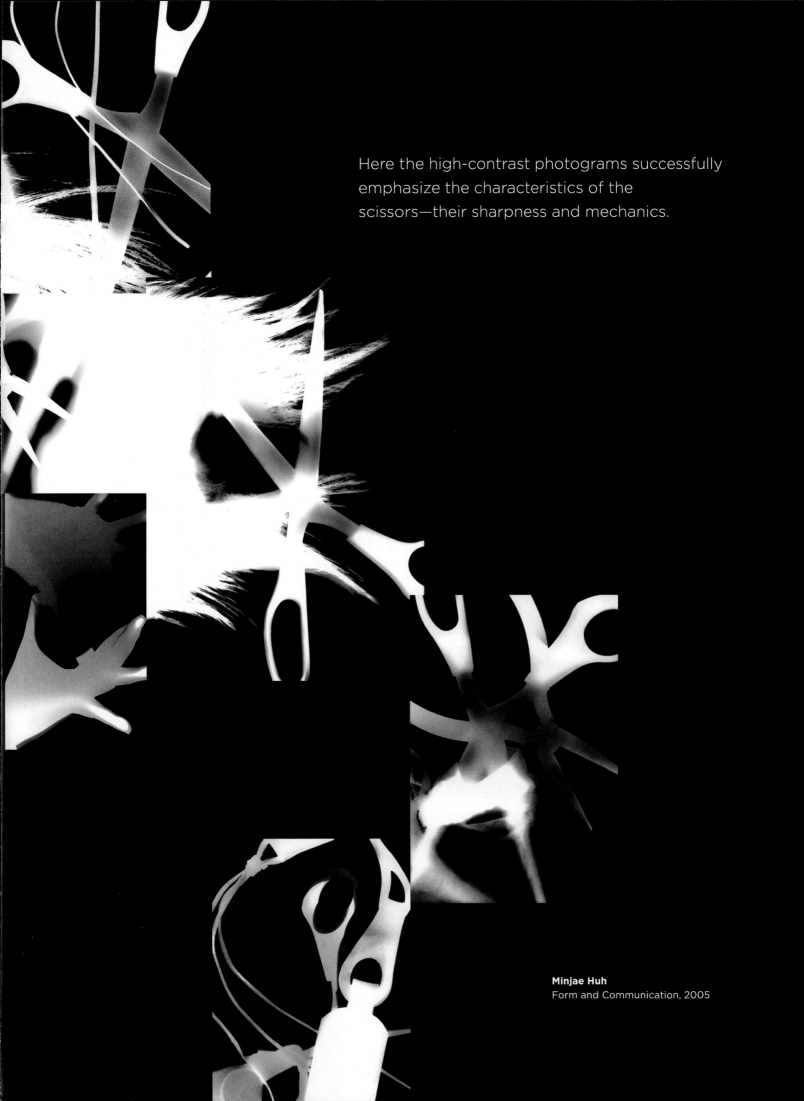

Here the high-contrast photograms successfully emphasize the characteristics of the scissors—their sharpness and mechanics.

Minjae Huh
Form and Communication, 2005

The shape of a clear glass object is partially defined by the highlights it captures. Documented through the photogram process, the very similar highlights are recorded in a reverse pattern.

JENNIFER WHITNEY

In the beginning, I experimented with many different objects. I used sea glass, my hands, fish net stockings, magnets, chains, and wire. I experimented with different time settings and explored different techniques with water and developer. During my process I used a filled water bottle and decided to explore the object further. I emptied it, filled it, used only one, or several. I rolled it across the paper, or left it standing up. I found the results interesting so I decided to create my final composition with the water bottle photograms. It was hard for me to find a solution using my original photograms.

Many of the images didn't seem to make sense when I first combined them. I decided to scan them in and explore cropping options. I came up with several compositions that appeared too symmetrical. Later, I returned to my cropped images and decided to integrate the forms more. I included three solutions in my final, I am not completely happy with any of them but I think they are the best solution I have for now.

MAX ACKERMAN

This series of ten photograms explores the theme of motion and space through circles.

A gradation towards center of a circle creates the illusion of a tunnel, which is symbolic of both motion and space. The use of concentric circles illustrates rippling, or wave motion.

I used drinking glasses to create the photograms for their distinctive properties.

When light passes through the glass it is suggestive of water, and helps create the image of ripples. The changes in thickness through the bottom of the glasses works like a lens, focusing the light, this creates the tunnel effect. Glass also distorts light in a very unpredictable way, which creates interesting surfaces that could not be anticipated.

OPPOSITE
Kwangyong Lee
Form and Communication, 2005

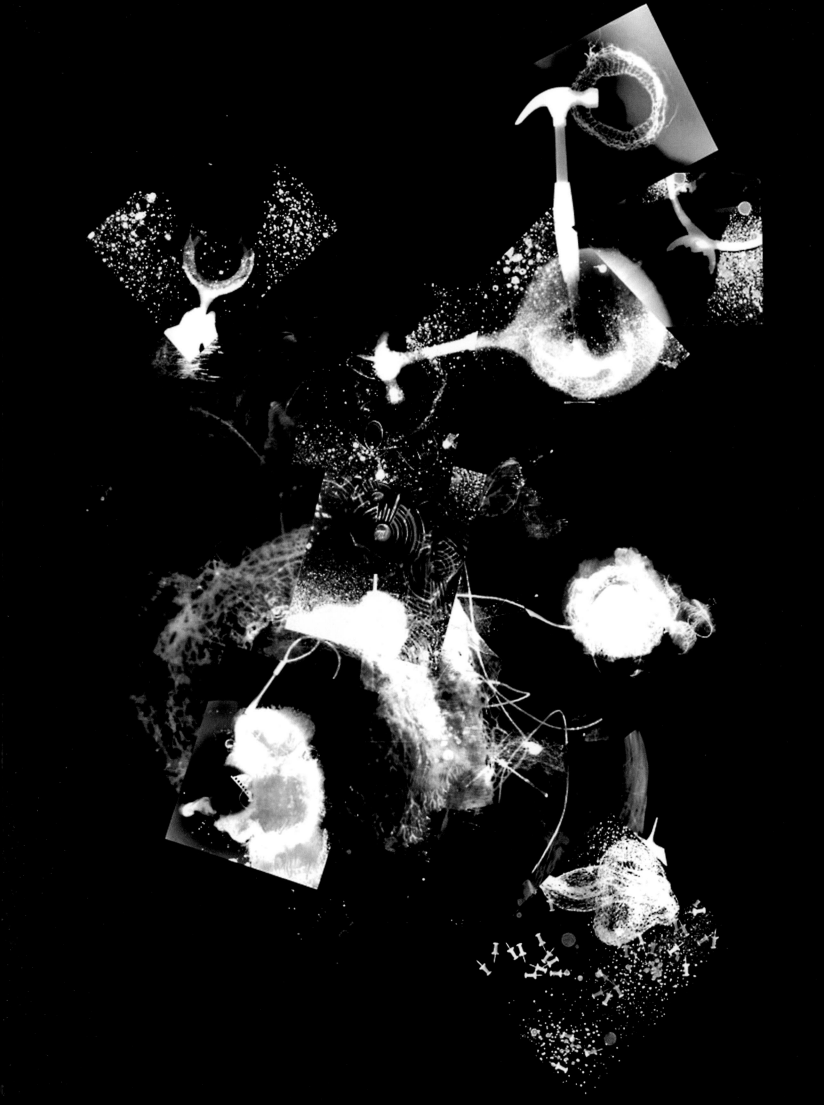

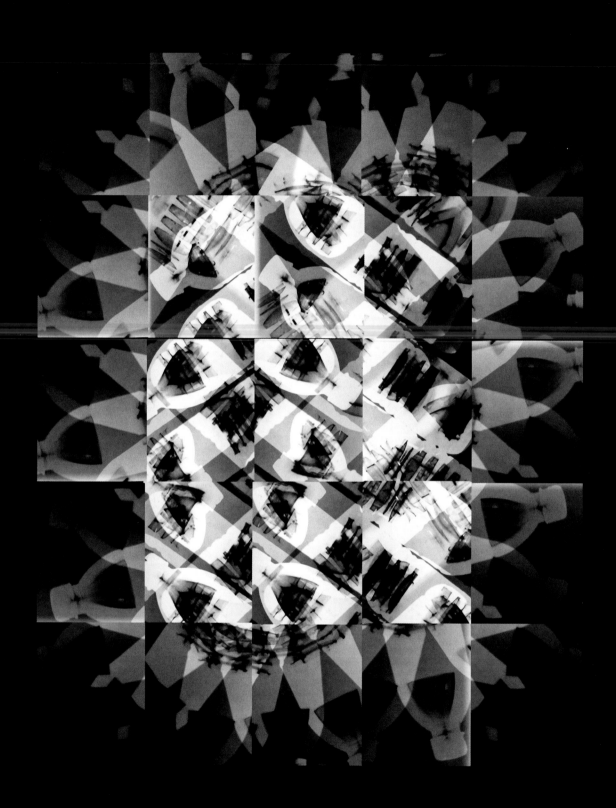

Jennifer Whitney
Form and Communication, 2006

OPPOSITE
Max Ackerman
Form and Communication, 2007

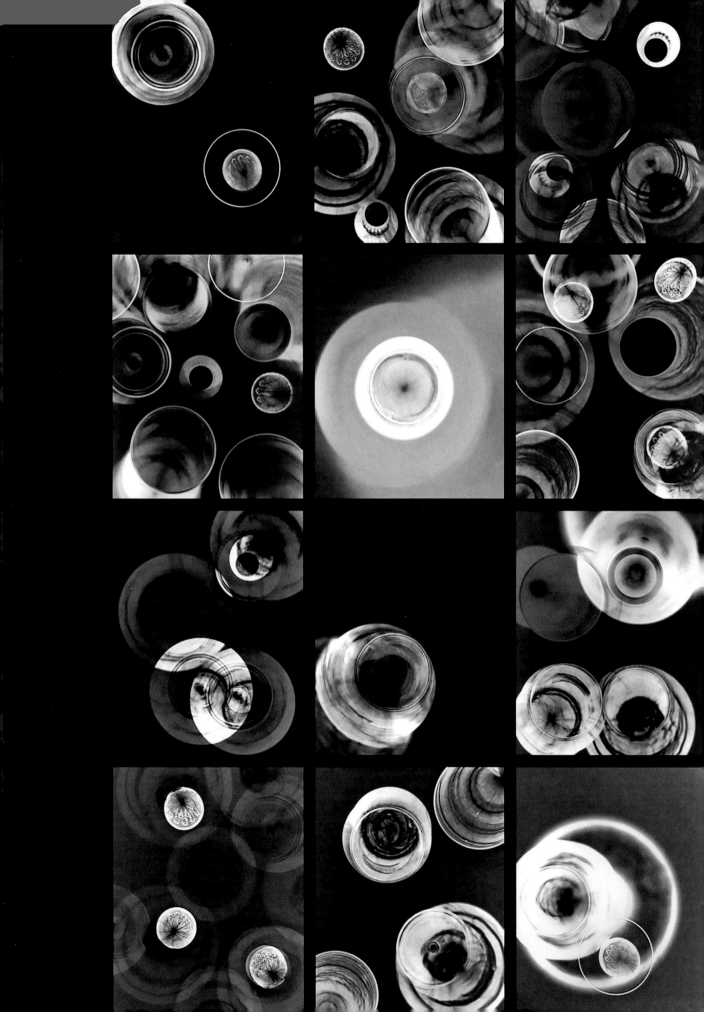

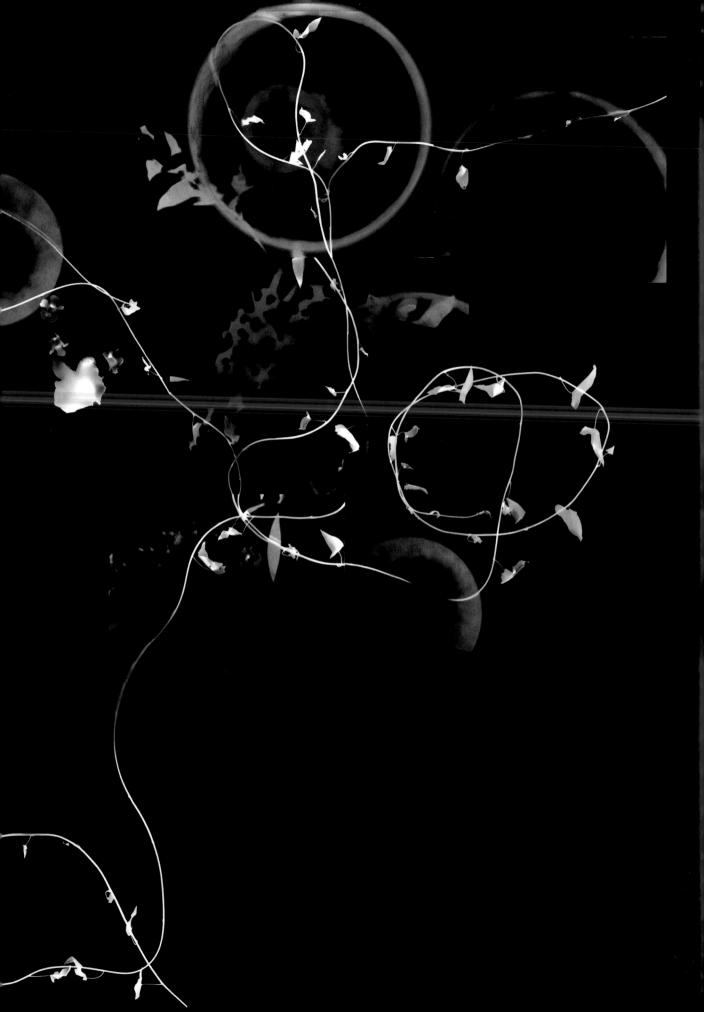

In using string for material, the designer creates a simpler composition, since there are many connection points to link the different elements.

ELANA WETZNER

For my photogram project, I decided to focus on images of water, reflections, plant life, the night sky, moons and planets, shadows and light, tangled vine-like lines, and fluid rhythms.

I had filled my mind with remembered images of found abstractions in the natural world: walks taken in the woods or by water at night, and photographs by Minor White, Edward Weston, Paul Caponigro, and Emmett Gowin, among others.

In the darkroom, I was most excited to try out Jello as a material, but I found that its coloring was too dark & filtered out too much light, leaving only a muddy shadow. Most of my forms were made by using vases, sections of a vine, water, various flowers, and glasses both with and without water in them. I had two levels of glass stages set up at my enlarger and was able to experiment with these different levels of projection, filtration, and layering.

I assembled my ten final prints in a single composition to create night scene of an endless vine which seemed to follow reflections of the moon across the surface of water.

Elana Wetzner
Form and Communication, 2006

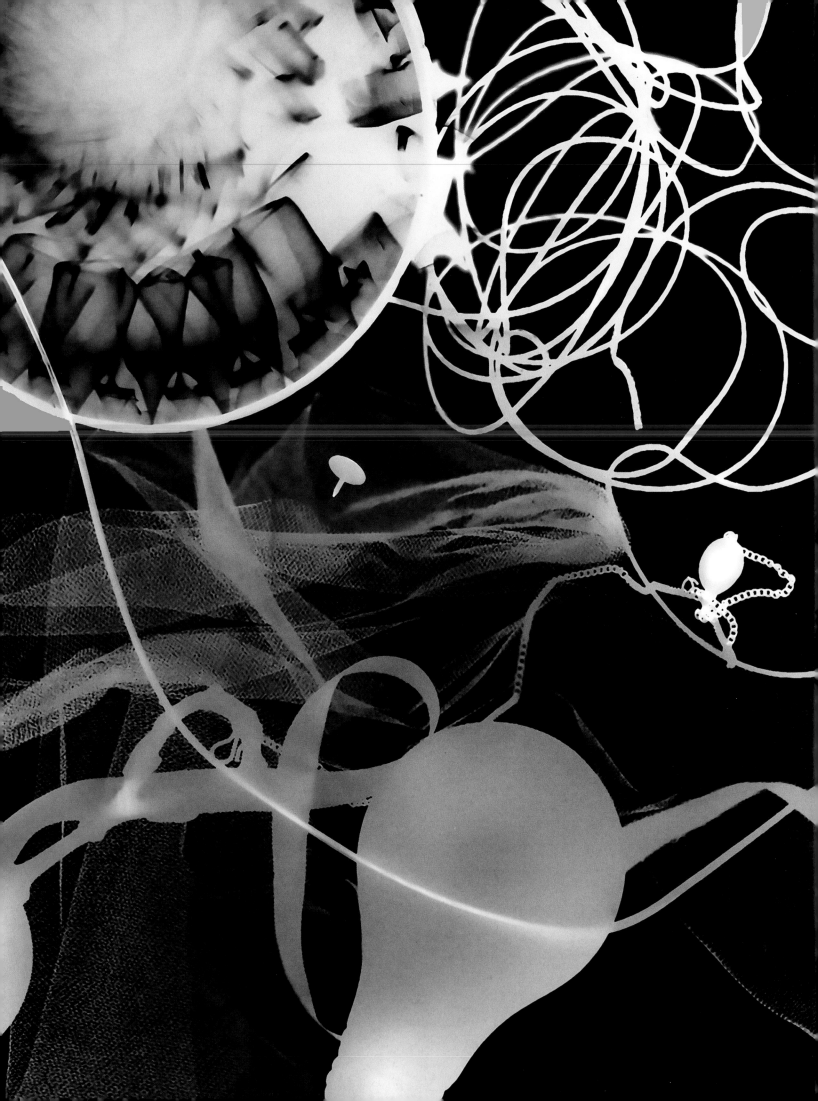

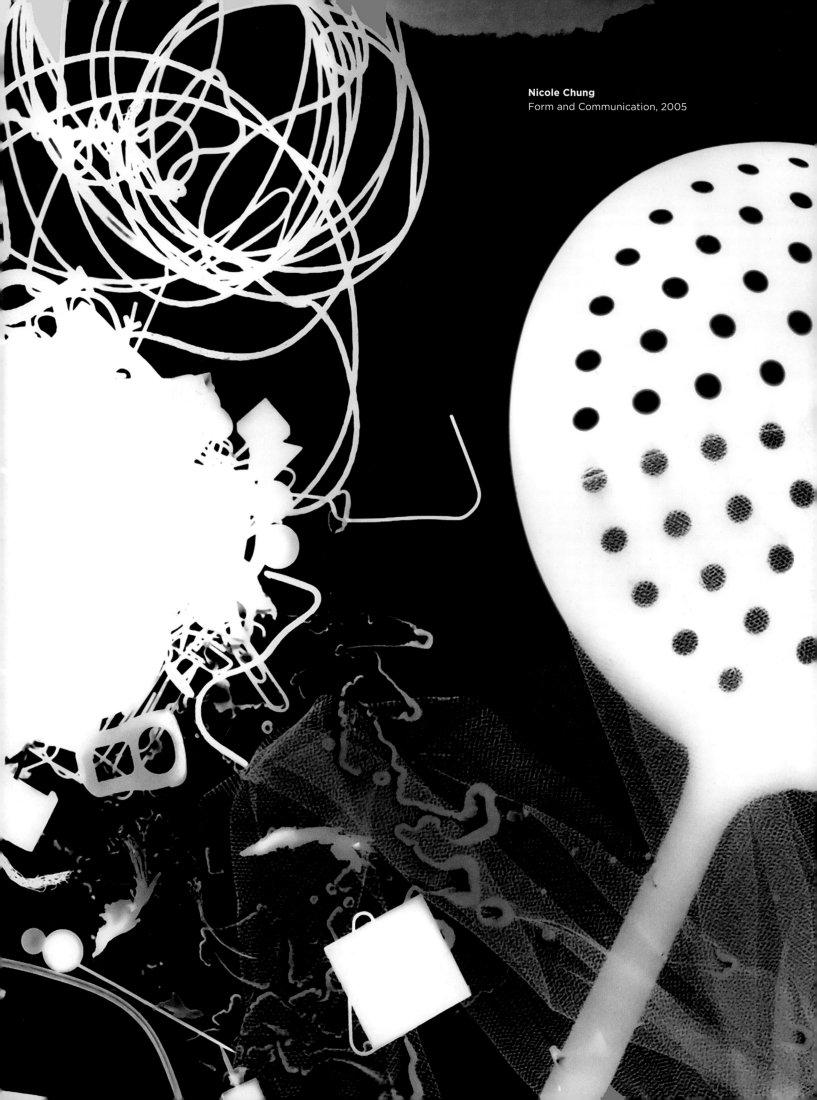

Nicole Chung
Form and Communication, 2005

MULTIPLE EXPOSURES

2

Using layered images as information in an other-wise fixed form is a dynamic tool in the field of visual communication. Transparency is a characteristic inherent to photography. Because of the realistic quality of photographs, layered images can take on a supernatural characteristic, like the ghostly image in an unexpected double exposure. A designer requires careful planning in order to employ a double exposure. Graphic designer Josef Müller-Brockmann created superb examples of multiple-layered photography, ingeniously integrated with typography. If the primary value of the layered image is to communicate a concise and unambiguous message, then there should be a sufficient difference between the two images; scale, density, and form are of prime importance. In other situations, the designer might prefer subtle and delicate handling of the image and less contrast, especially in instances where the content determines the treatment of the form.

For example, one of my black and white prints consists of a double exposure from two individual negatives. One exposure displays a top view of a sawn tree stump. This circular image occupies nearly the entire print. The reproduction quality is kept as original as possible—in other words, soft, organic, with a wide tonal range. The second exposure shows a telephone pole. Printing it with harder contrast emphasizes its linear quality. The surface texture and material characteristics of the telephone pole have faded, but it has not lost its identity. Through its appearance and context, the pole becomes representative of technology, progress, and the future. The illusion of the pole's shadow cast onto the stump adds an appropriate and mysterious touch.

The Process

A. Secure position of photo paper with tape. Project first image in enlarger onto photo paper with emulsion facing up

B. Remove exposed print from the first enlarger and place in designated position under the second enlarger

C. Project second image in enlarger onto photo paper with emulsion facing up

D. Remove the exposed photo paper

E. The exposed photo paper is submerged in the developer for approximately 60 sec

F. The developed photo paper is sumerged in the stop bath for 30 sec

G. The photo paper is submerged in the fixer solution for 120 sec

H. The print is rinsed in running water for 20 min and let dry

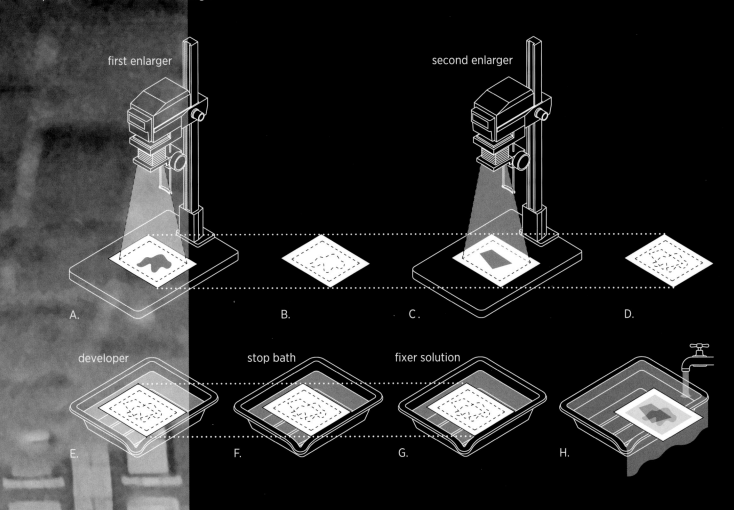

first enlarger

second enlarger

A.

B.

C.

D.

developer

stop bath

fixer solution

E.

F.

G.

H.

Chiai Takahashi
Photo/Graphics, 1990s

Materials and equipment

THE FOLLOWING MATERIALS ARE SUGGESTED:

- photo paper (of any grade)
- photo chemicals: developer, stop, and fix
- running water
- two negatives

A FULLY EQUIPPED DARKROOM IS IDEAL BUT NOT NECESSARY:

- photo paper must be handled only in a darkroom with red or yellow lights
- chemicals must be carefully handled according to the product description and disposed of properly

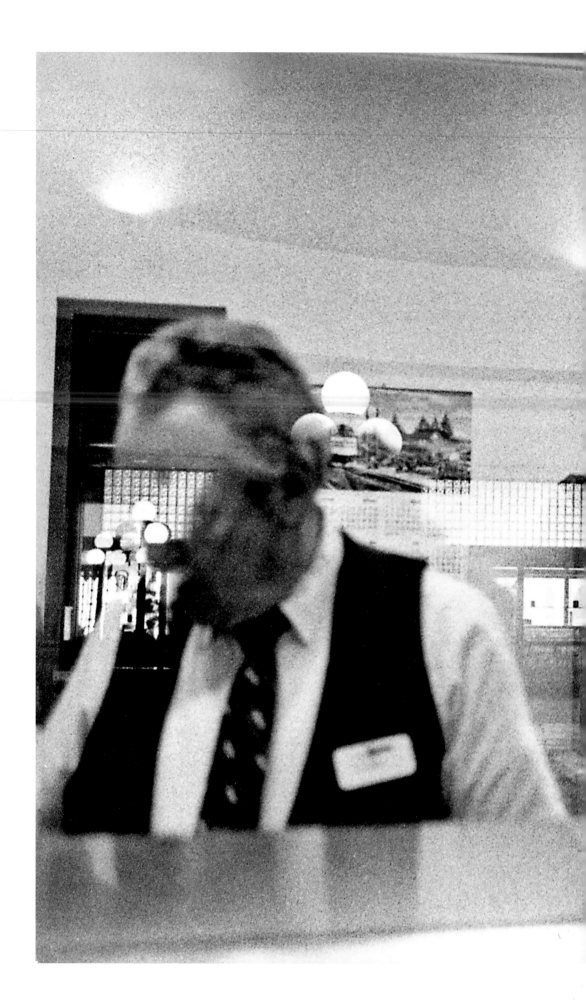

Robert Crowley
Photo/Graphics, 1990s

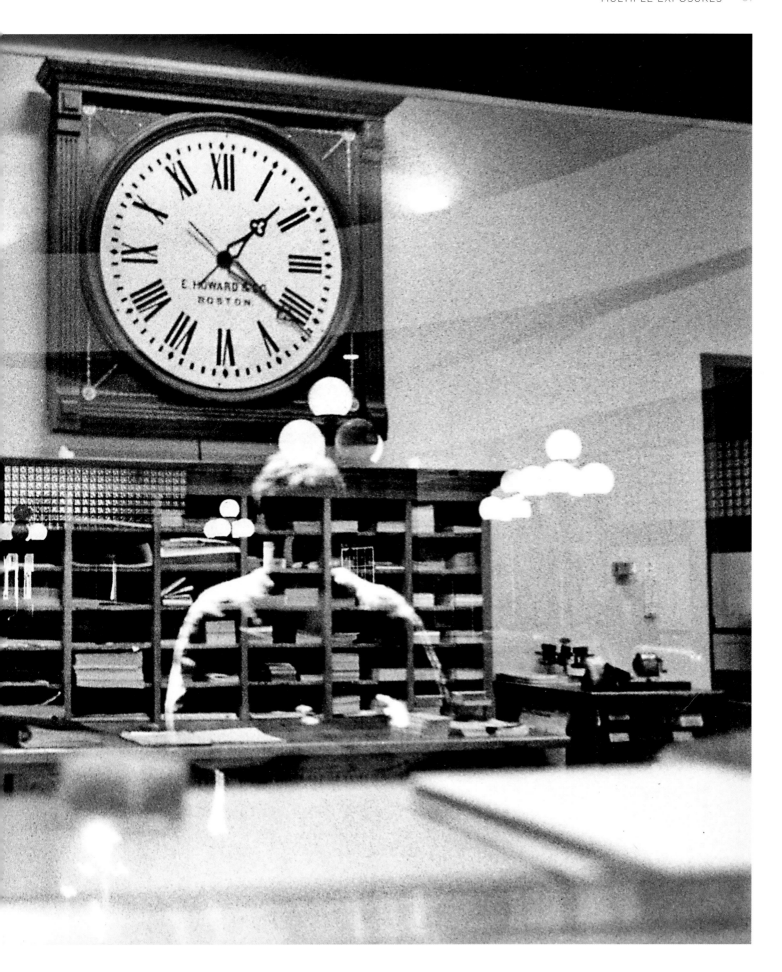

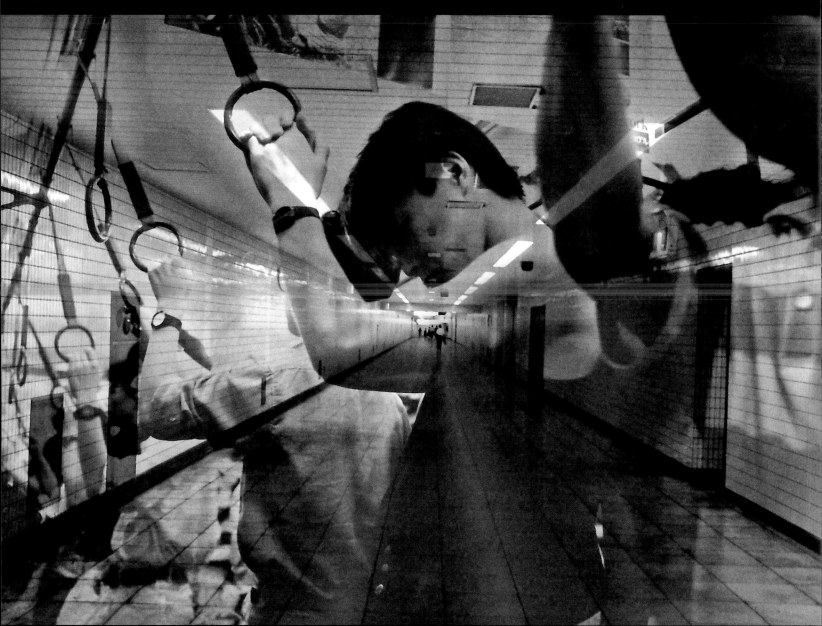

Performing a photo documentary in the subway
has positive and negative aspects. While the proximity
of interesting images can be quite contained,
the designer does not want to offend the passengers with
his or her explorations.

These double exposures did not happen by chance;
on the contrary, they were carefully created with a clear
message in mind.

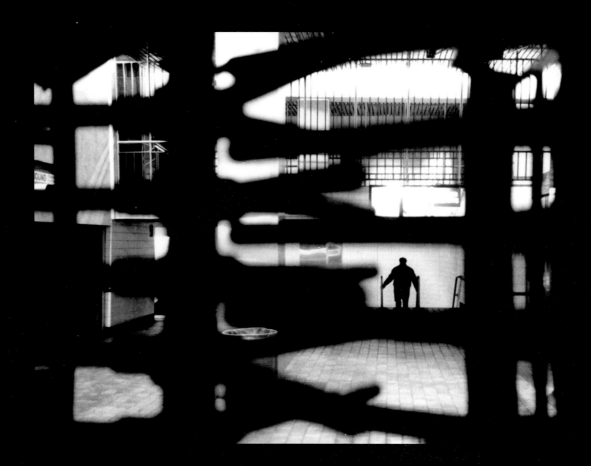

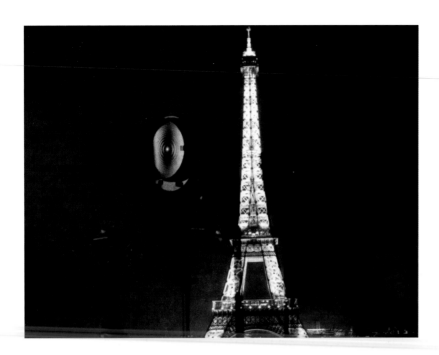

Jean David Boujnah
Photo/Graphics, 1990s

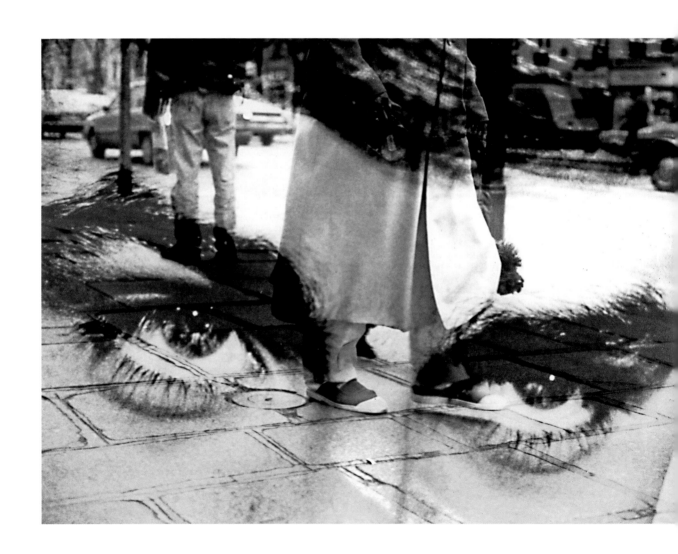

A successful double exposure is not solely based on two
clever photographs, but also on how well the formal characteristics
of each picture combine with the other.

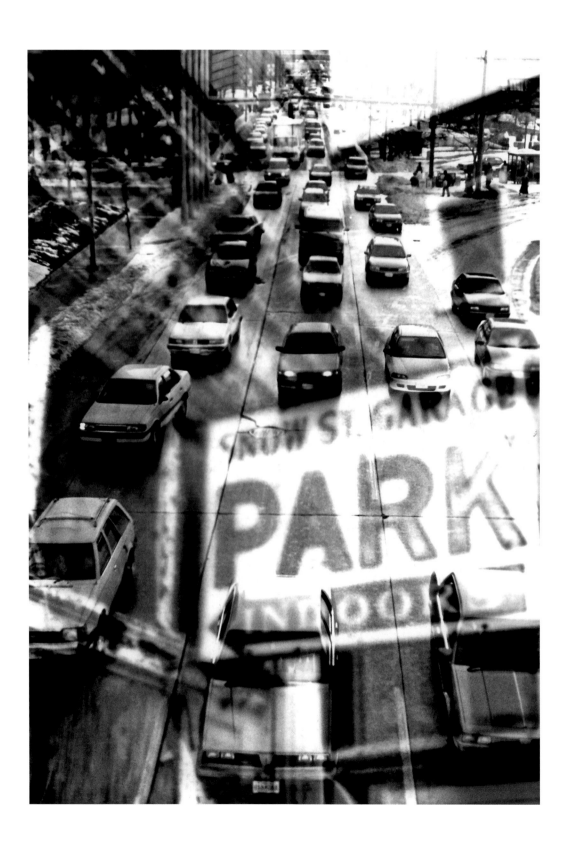

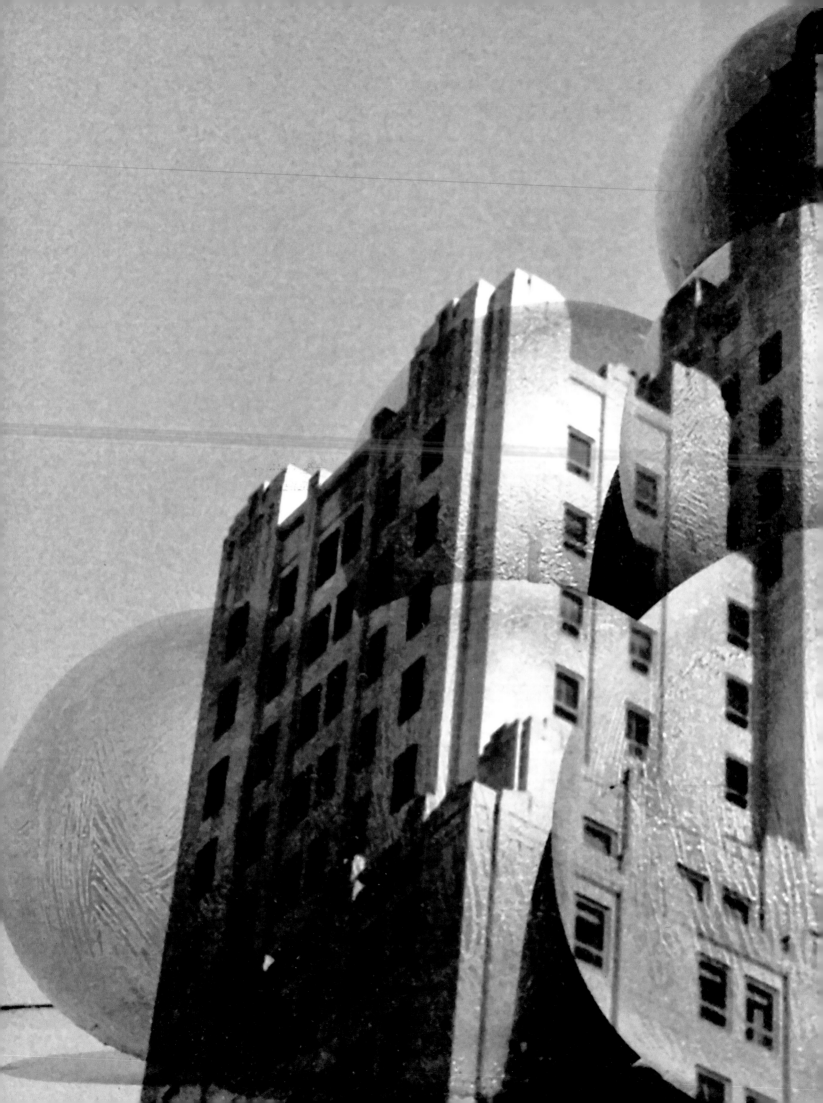

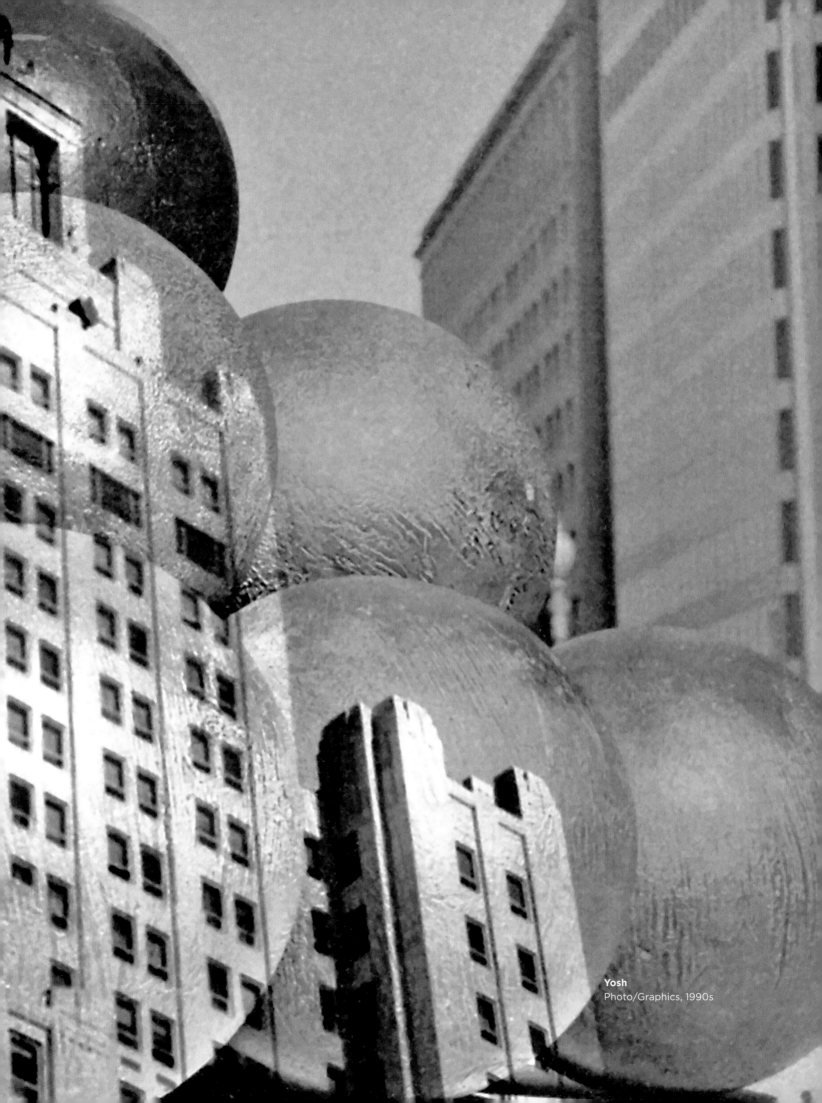

Yosh
Photo/Graphics, 1990s

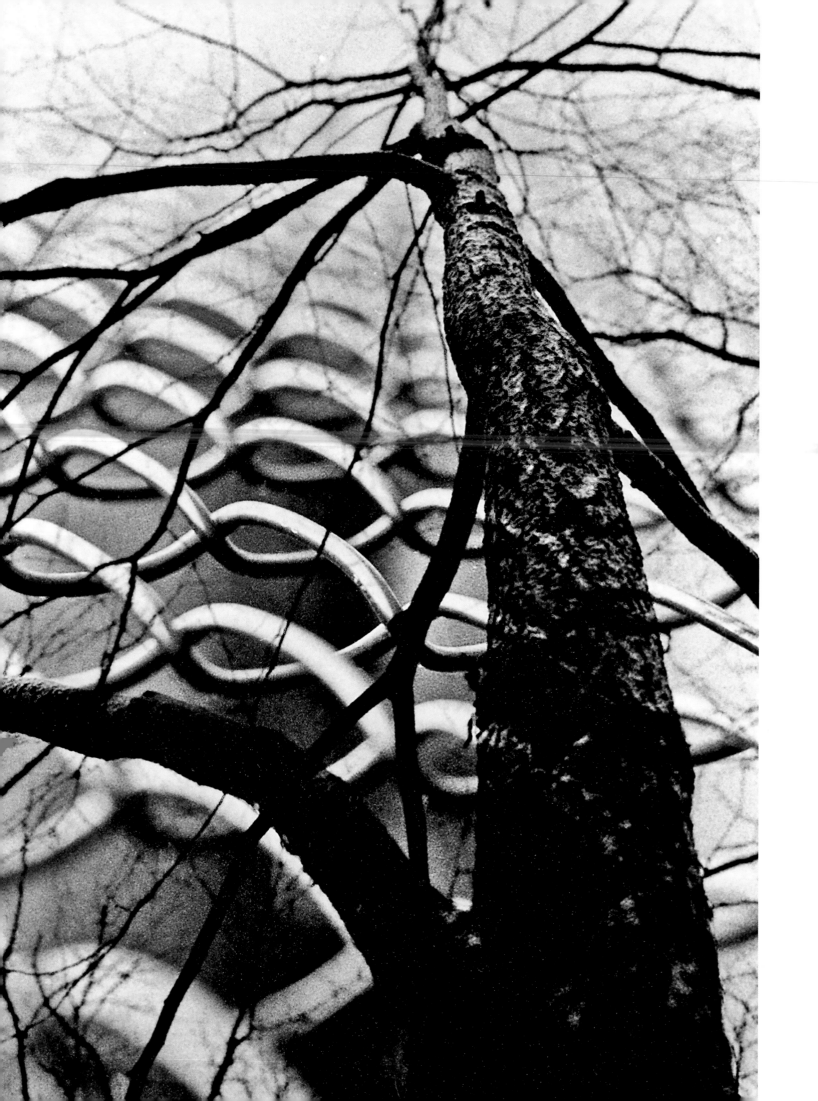

OPPOSITE
Marisa Murgatroyd
Photo/Graphics, 1990s

Erik Kuniholm
Photo/Graphics, 1991/92

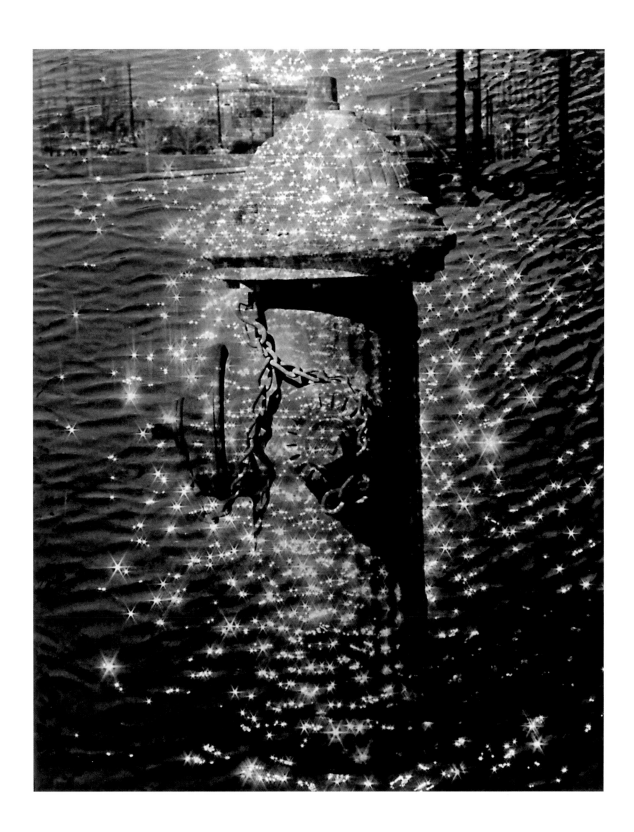

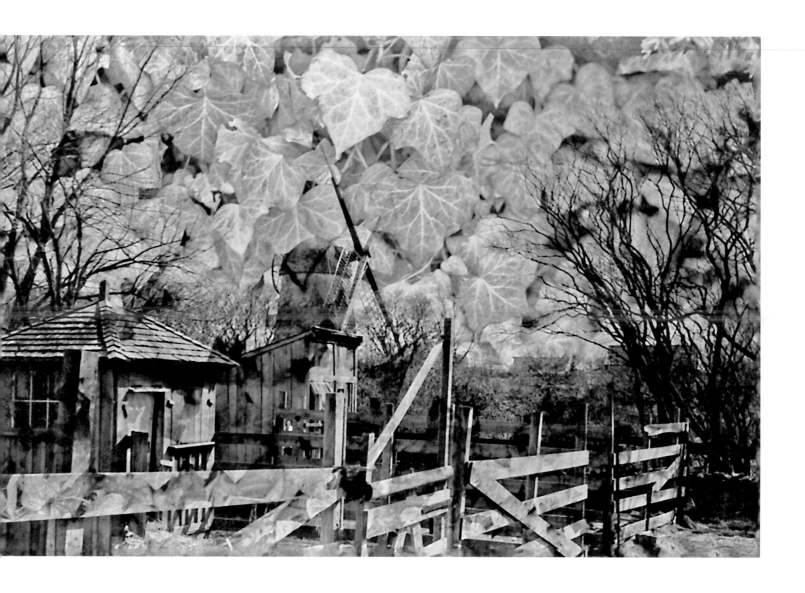

Chiai Takahashi
Photo/Graphics, 1990s

When students experiment with the multi-exposure technique, they often recycle images that already exist.

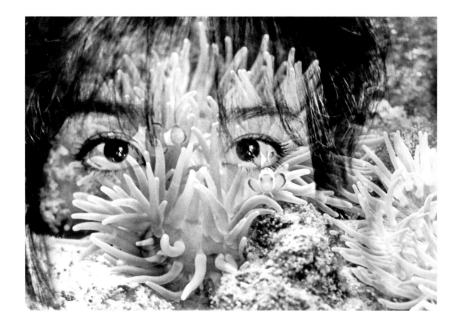

Kathleen Snyder
Photo/Graphics, 1990s

Anne Chequer
Photo/Graphics, 1990s

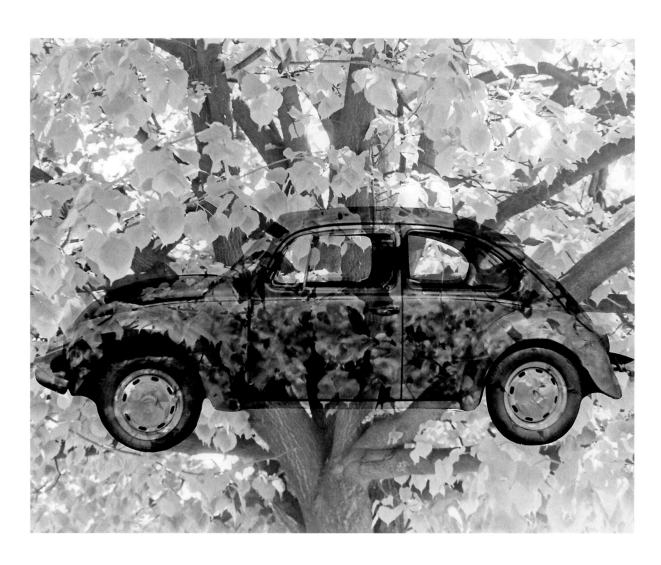

With this arrangement of multi-layered images, the student was able to create an exaggerated close-up. The situation feels imposing, and the final composite could be interpreted as a bit aggressive.

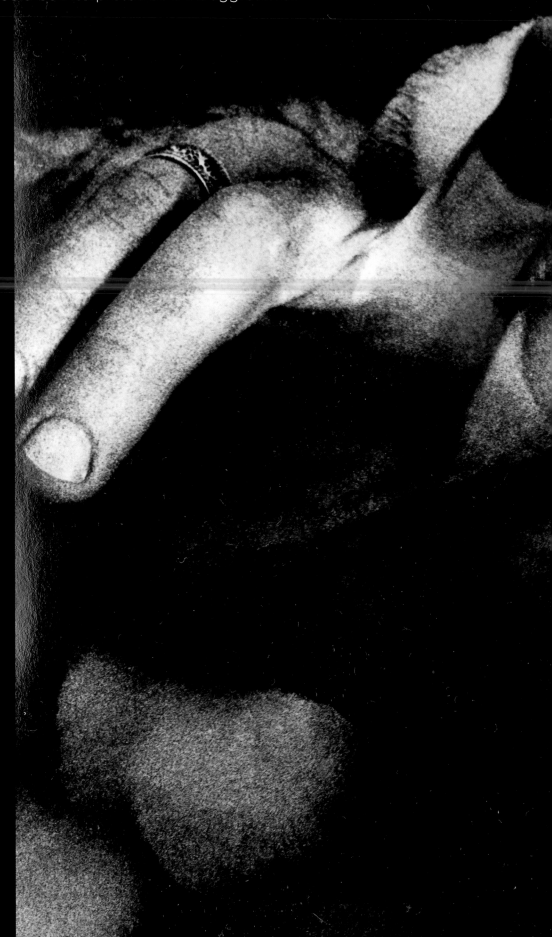

Kathleen Snyder
Photo/Graphics, 1990s

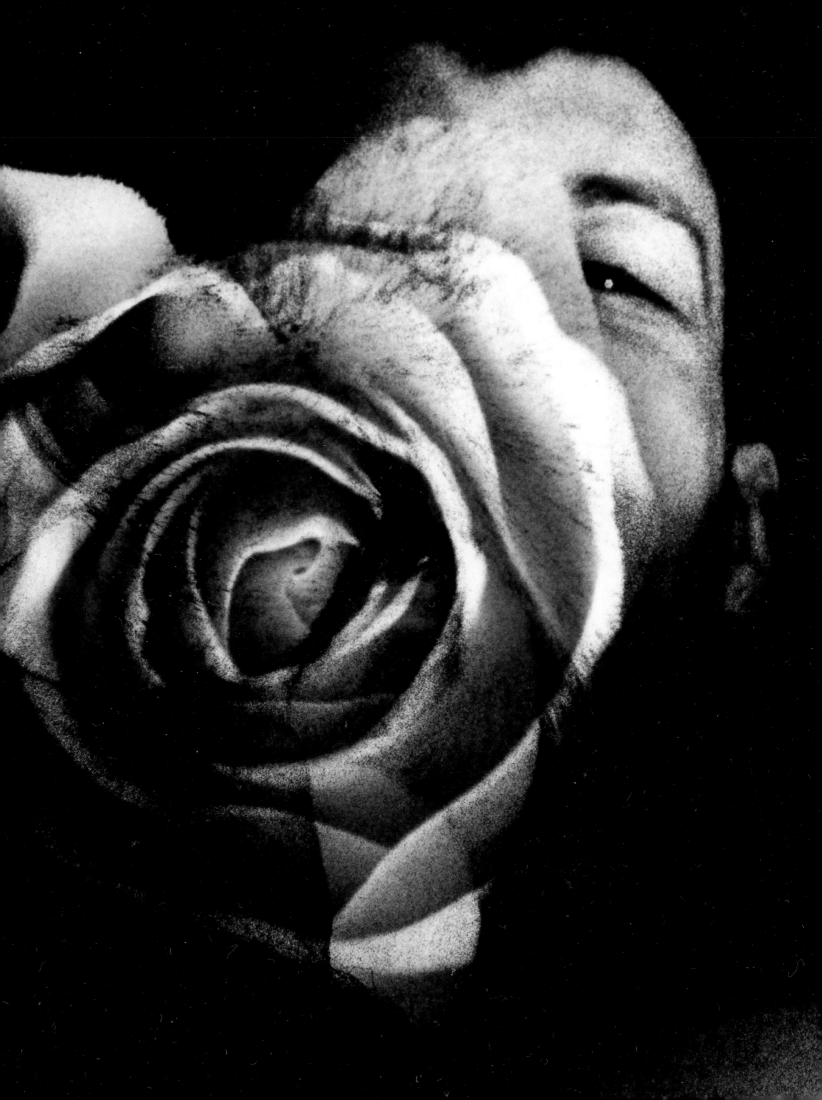

OPPOSITE
Sarah Cuno
Photo/Graphics, 2005

Unknown
Photo/Graphics, 1990s

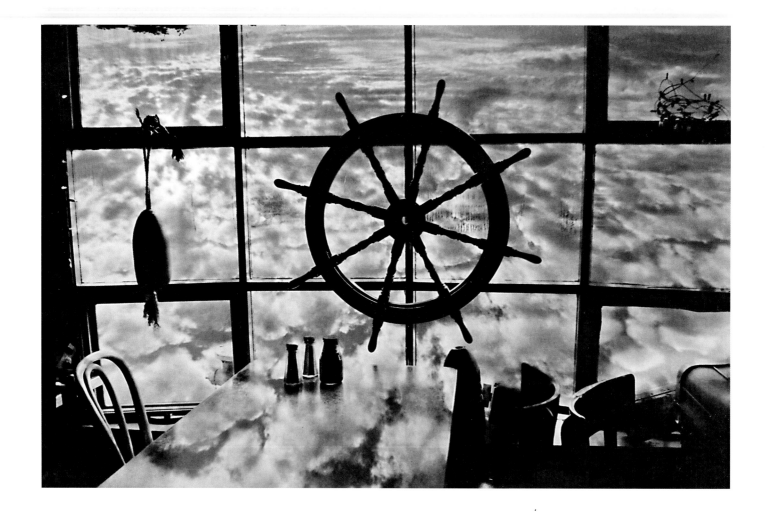

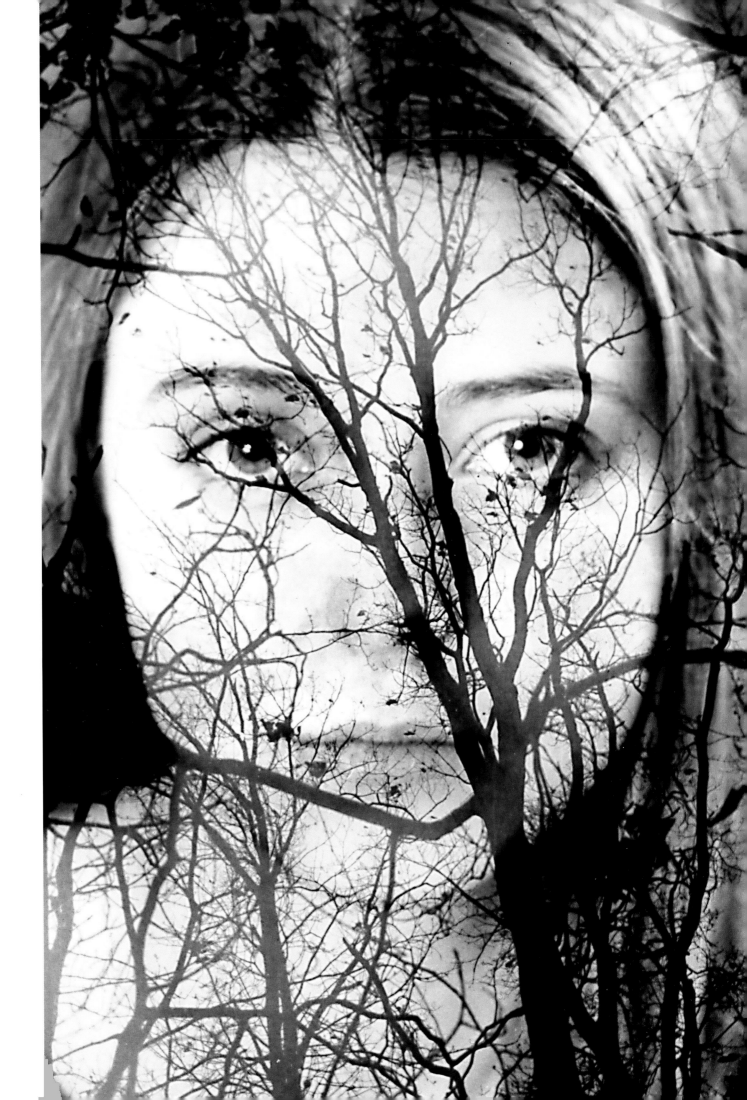

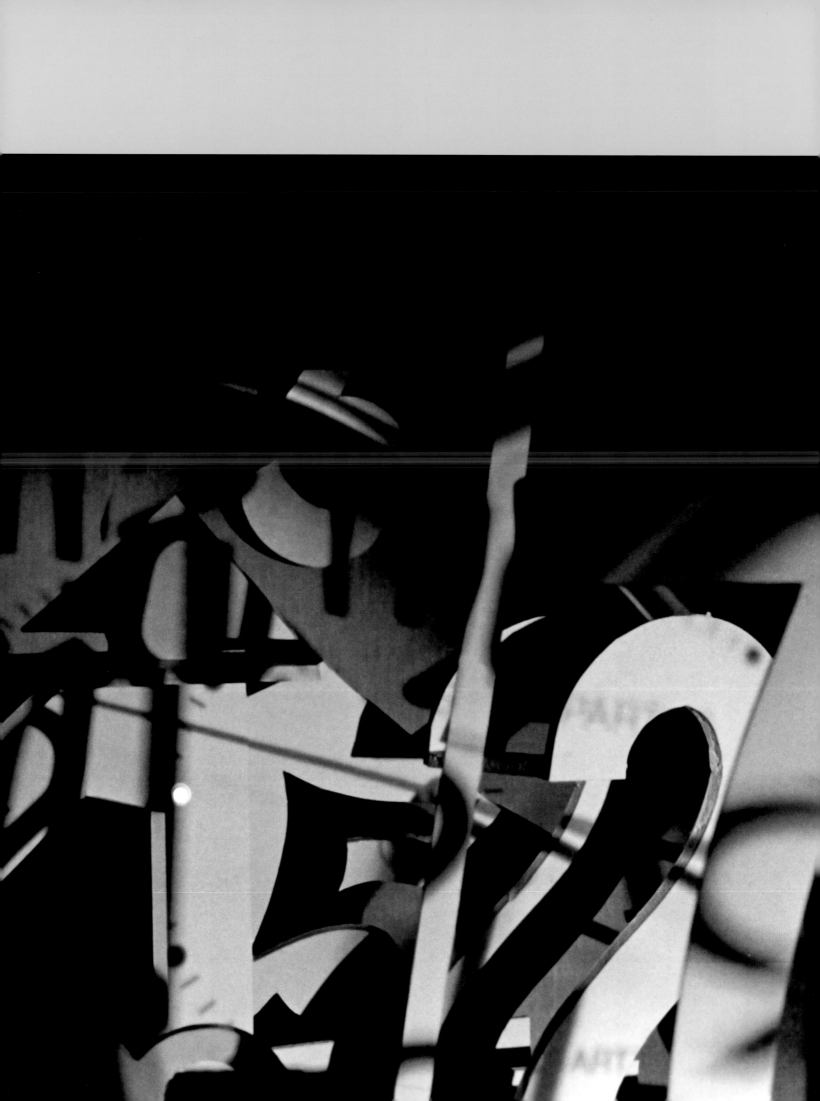

3

Staged photography is designing and building an entire set specifically to be captured with a camera. Such photography carries within it the feeling of the stage and hints at the underlying excitement of the theatrical.

Staged photography has three unique components: two-dimensional, three-dimensional, and lighting design.

Two-dimensional design is the creation and arrangement of flat shapes that are suspended, supported by panes of glass, or cut out of the set's backdrop. The coordination of these shapes also requires a sense of compositional organization, since the final photograph will also be two-dimensional.

Three-dimensional design is the arrangement of objects such as props and the human figure within the staged area itself. The act of positioning these objects requires the students to consider space and volume. Through the construction of sets and selection of props, the students become sensitive to formal relationships.

Lighting is a crucial tool in staged photography. Students learn that the alteration of lighting affects the viewer's perception of the subject. Alternative light sources, such as candlelight or fluorescent light, alter warmth and tone and evoke different emotional responses. Using a digital or slide projector, students can also superimpose text or images onto their sets. These images can be distorted or unfocused, which allows for a play of layered textures. Lighting is such a dynamic tool that it can completely transform both the formal and emotional aesthetic of the set.

How It V

A. Camera attached to tripod, angled downwards, framing the 3-letter composition

B. Low-wattage light source from above will cast shadow

C. Low-wattage backlight will make cutout letter "N" appear very bright

D. Roll of backdrop paper will create seamless background

E. Two sheets of plexiglass approximately 10" apart

F. Wooden blocks are used to support the plexiglass

A. Camera attached to tripod, zoomed at letter arrangement "FIN"

B. Low-wattage backlight will make cutout letter "N" appear very bright

C. Low-wattage light source from above will cast shadow

D. Roll of backdrop paper will create seamless background, pulled across the tabletop

E. One sheet of plexiglass approximately 30" from backdrop paper apart

F. Table at least as wide as backdrop paper

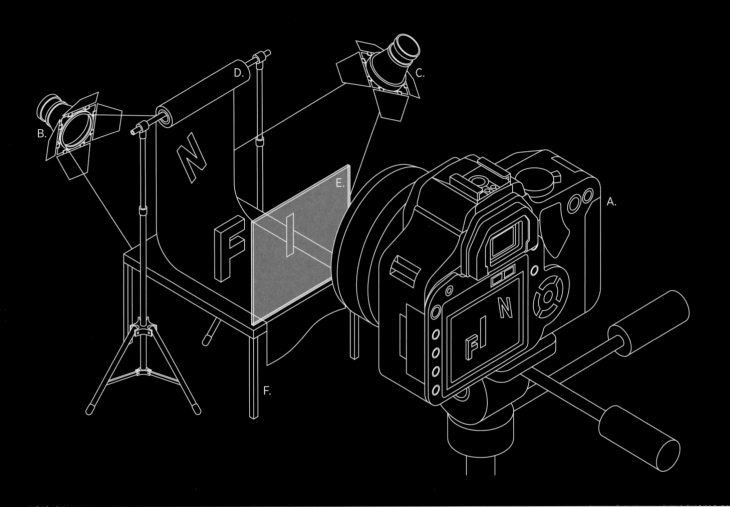

Materials and equipment

- camera
- tripod
- adjustable stands for the backdrop paper and lights
- 2 or more low-wattage light sources

- roll of white backdrop paper with letter "N" cut out
- 10" tall 3-D letter "F" constructed out of white Bristol board
- 12" tall letter "I" cut out of thin white paper

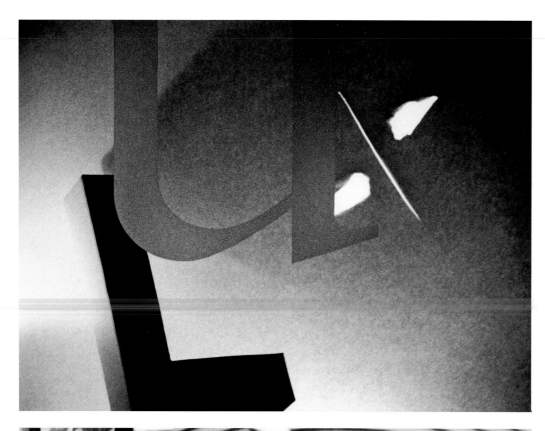

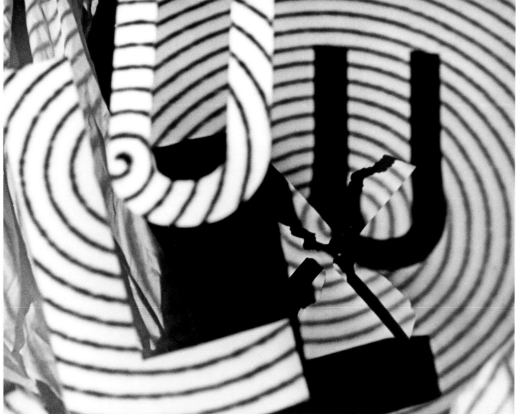

OPPOSITE
Sheila Mansolillo
Photo/Graphics, 1990s

OPPOSITE BOTTOM
Laura Cary
Photo/Graphics, 1990s

Susan Yoon
Photo/Graphics, 1990s

Here the term "designing with light" is demonstrated quite well. We can easily recognize some of the pieces' main characteristics, which are exhibited on both pages with high contrast in soft and hard forms.

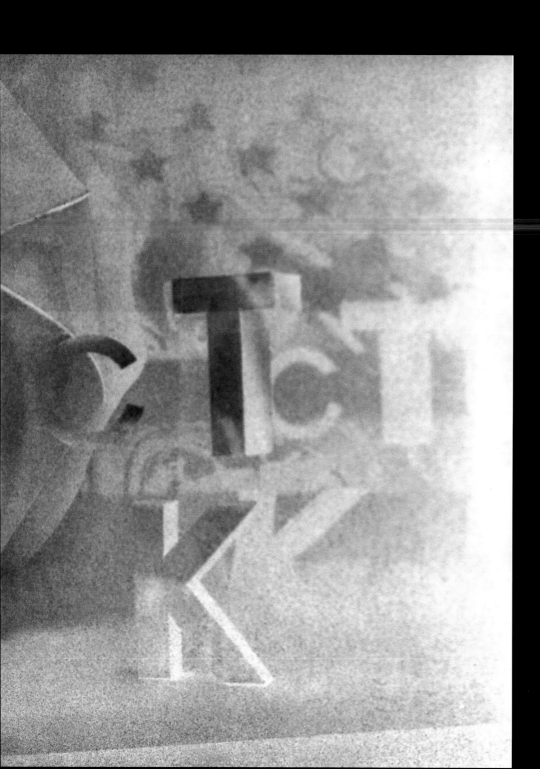

Unknown
Photo/Graphics, 1990s

OPPOSITE
Kathleen Snyder
Photo/Graphics, 1990s

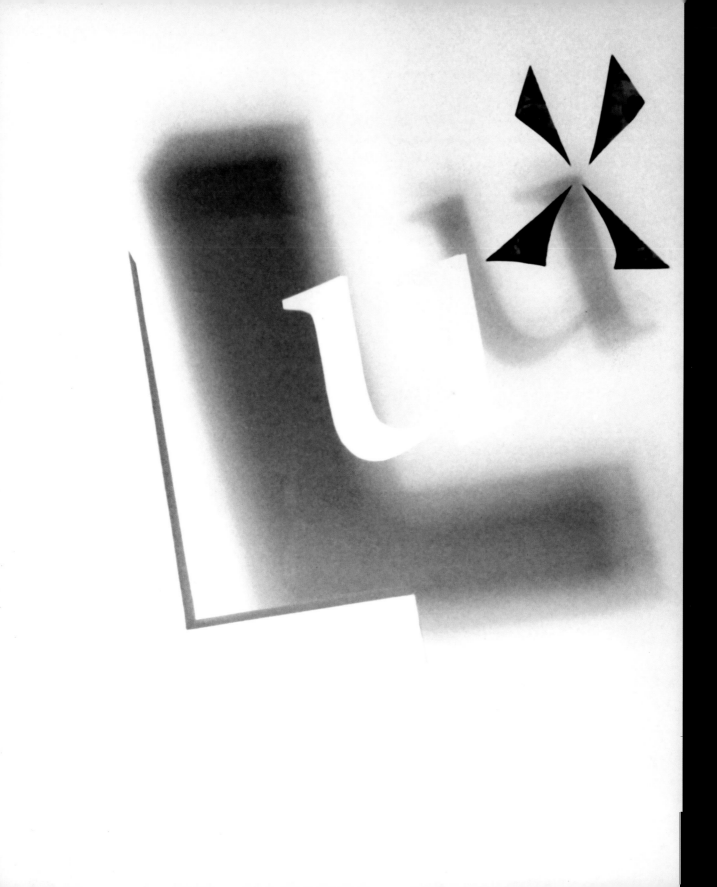

Boyoung Lee
Photo/Graphics, 1990s

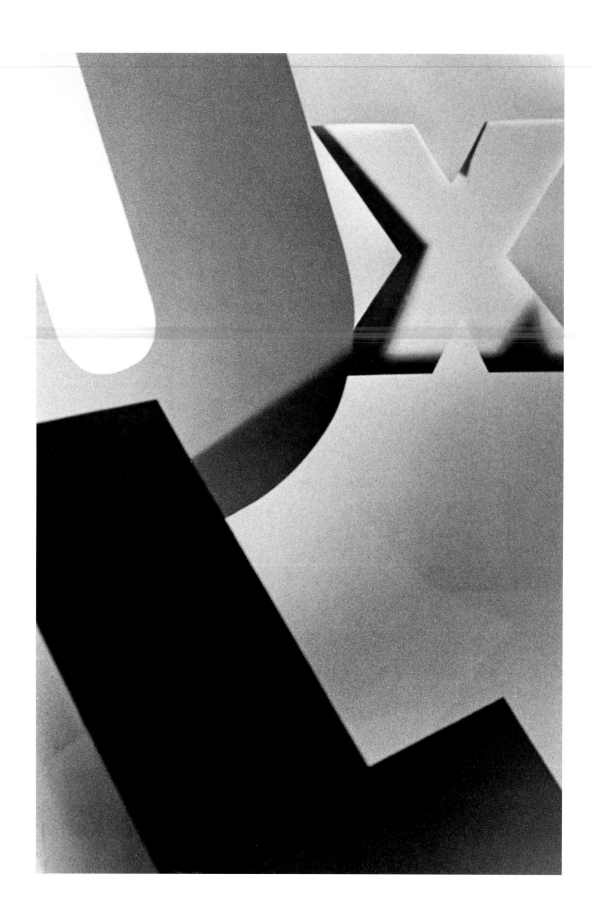

Beth Craver
Photo/Graphics, 1990s

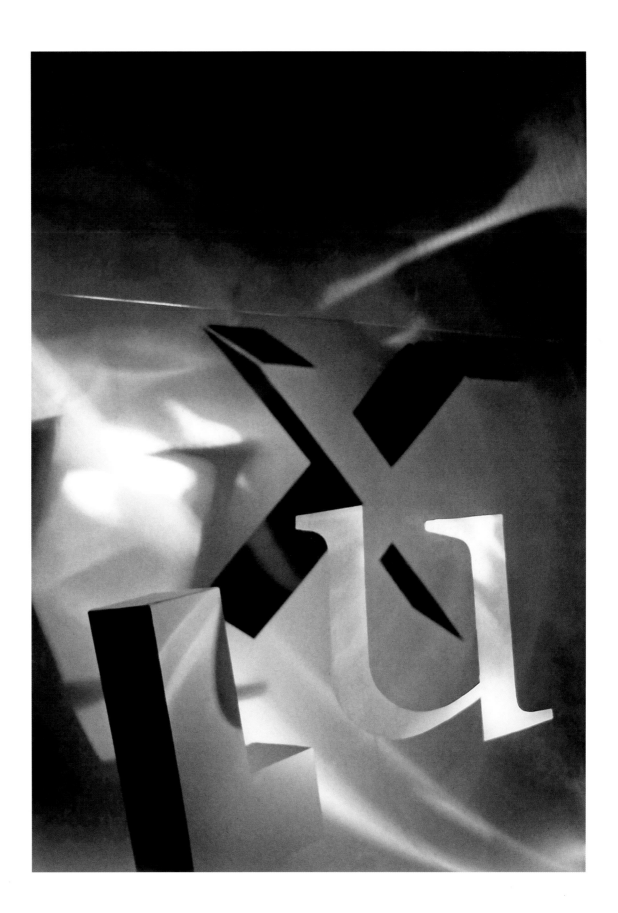

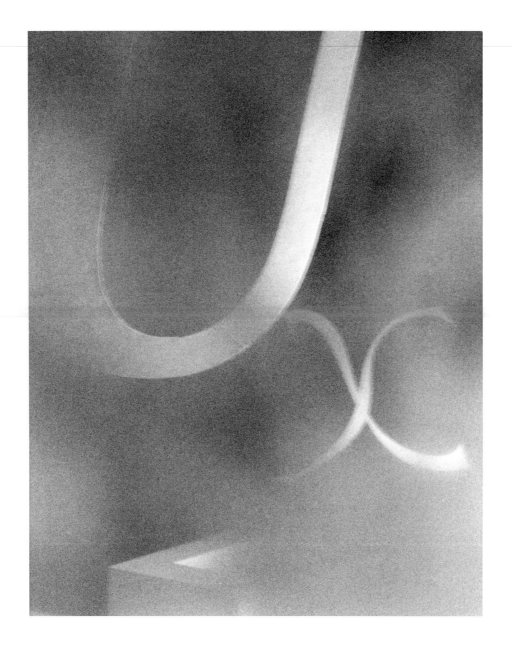

M. Contopoulos
Photo/Graphics, 1990s

OPPOSITE
Susan Yoon
Photo/Graphics, 1990s

Each of the letterforms takes on a personality: the "U" appears euphoric, while the "X" dances, and the "L" rests.

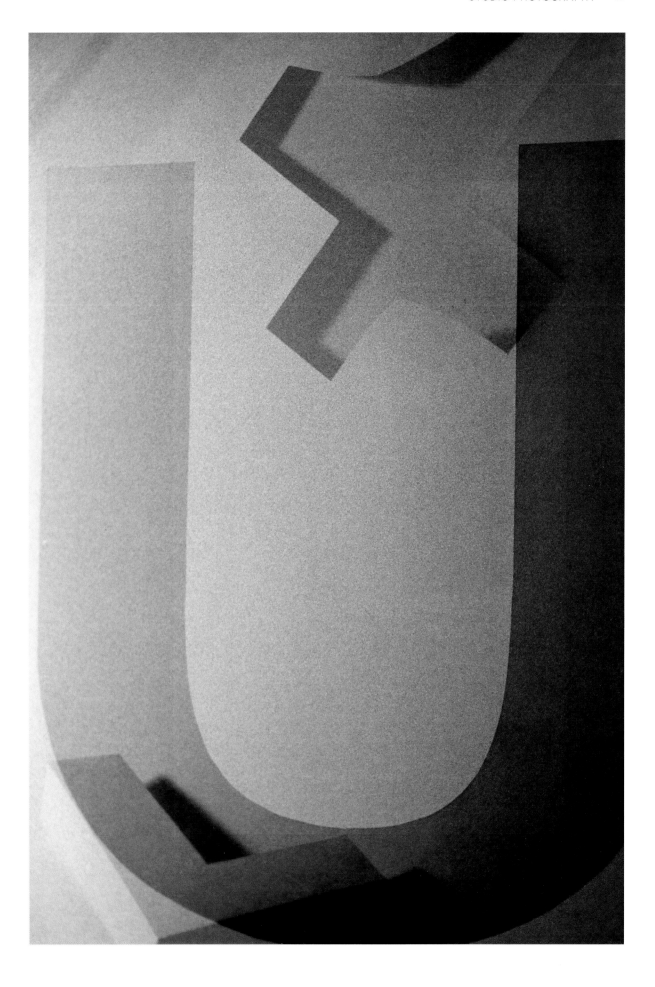

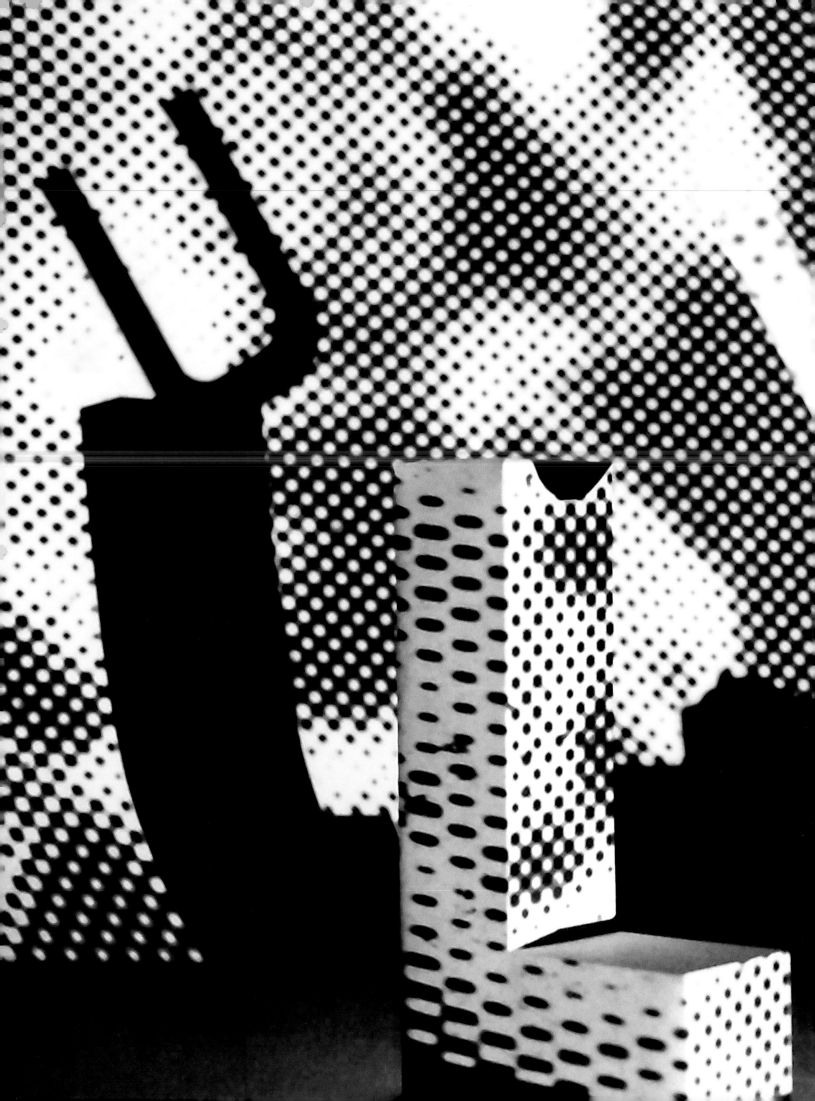

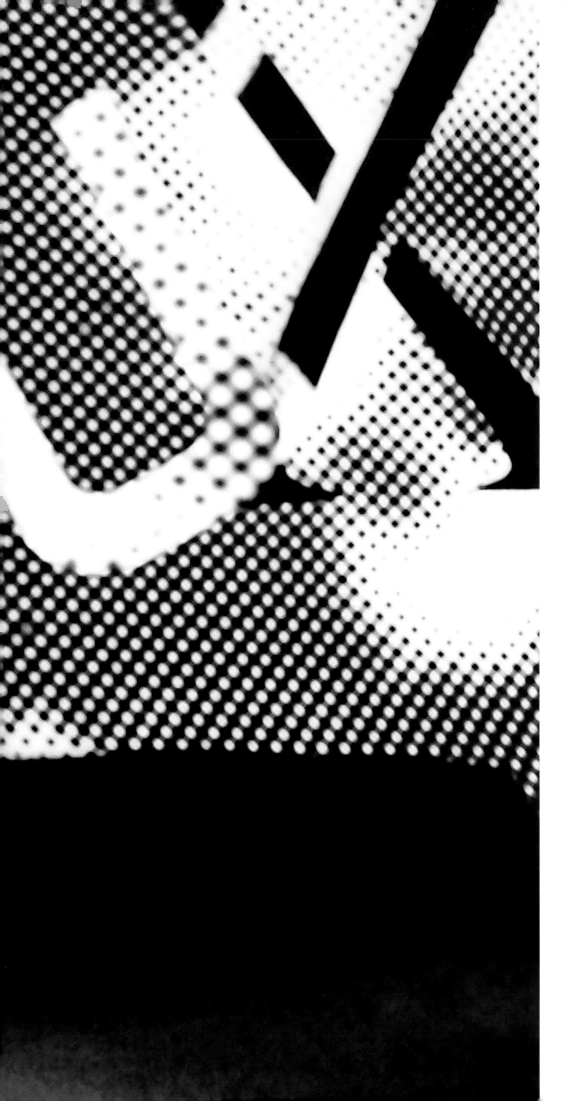

Yosh
Photo/Graphics, 1990s

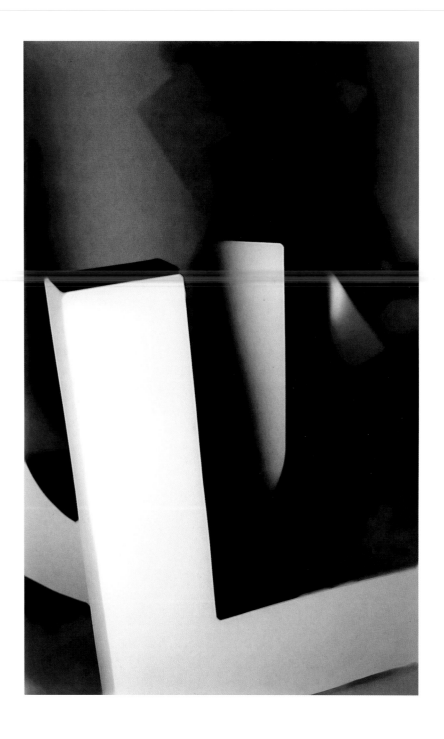

Christina Cook
Photo/Graphics, 1990s

OPPOSITE
Unknown
Photo/Graphics, 1990s

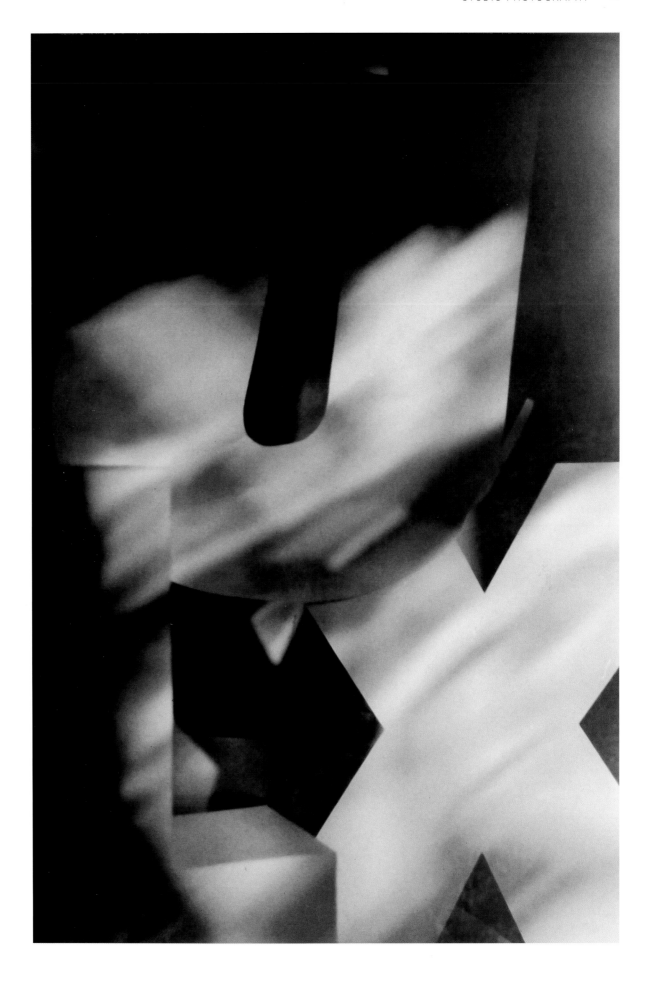

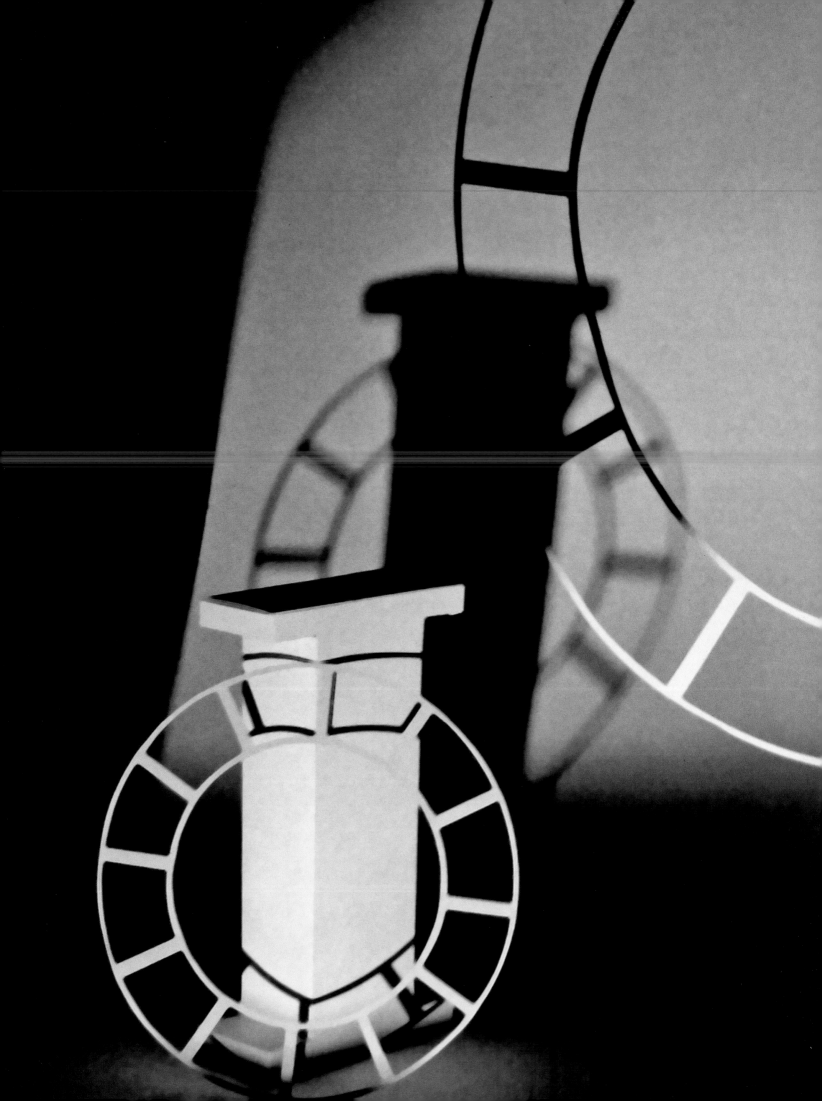

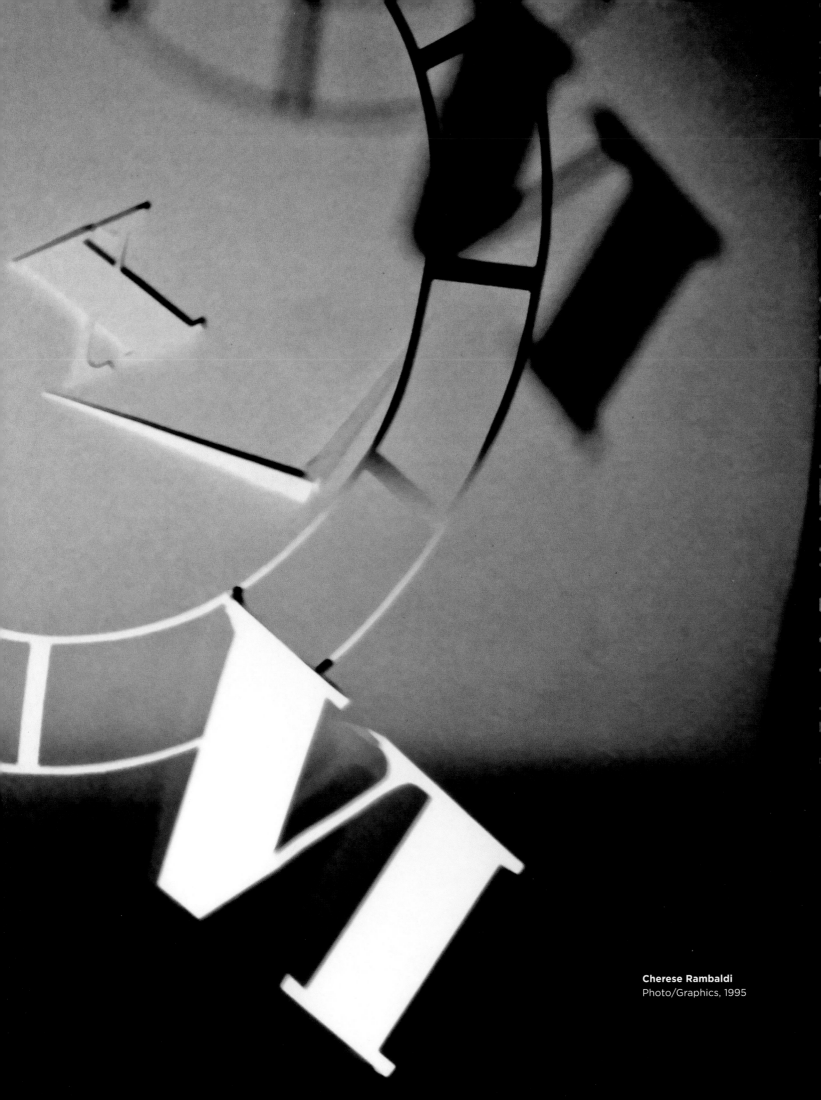

Cherese Rambaldi
Photo/Graphics, 1995

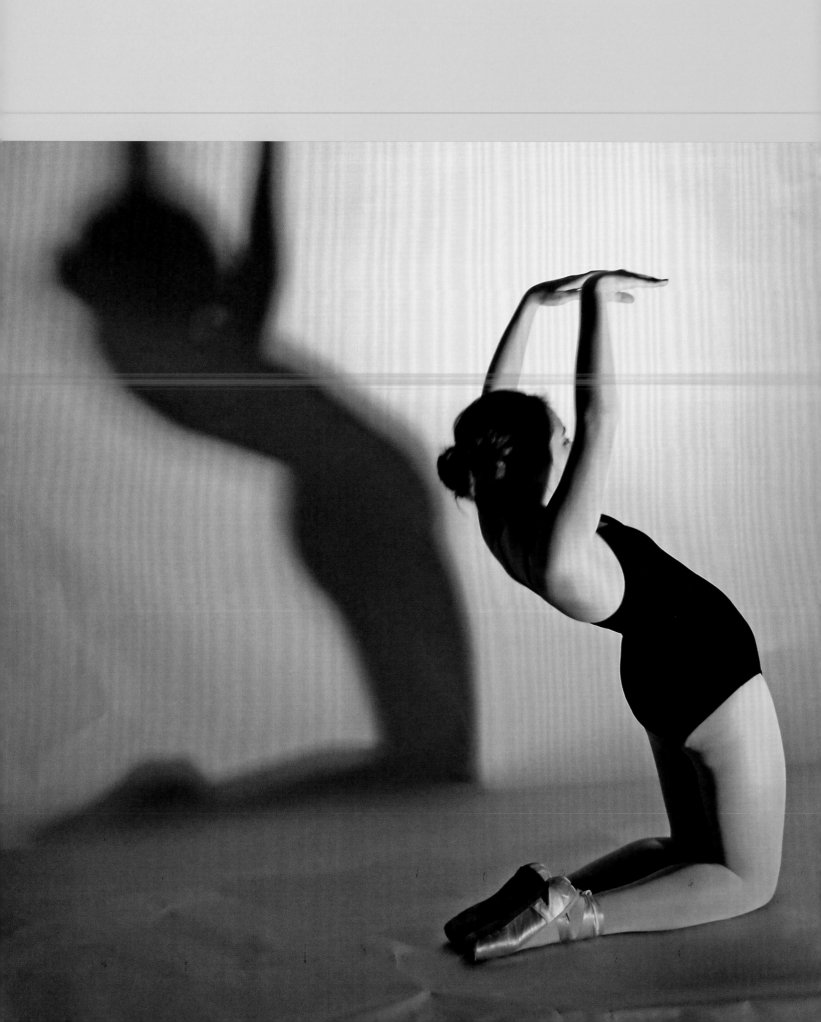

4

The human alphabet assignment is the perfect way for graphic designers who have an interest in photography to explore the medium. Due to time constraints and the workshop nature of this assignment, the resultant images are always unique. During the exercise, the focus of the students generally shifts from a formal focus to a more concept-oriented approach. Since time does not allow for the fine-tuning of form, the students tend instead towards a strong conceptual foundation.

I introduce the project to the students by referring to illuminated manuscripts, which often include anatomical initials. During the eighth century, we find beautiful and well-intergraded examples of such anatomic initials with letterform and image. Some of the illuminations were meaningful; others were merely for decoration. Even monasteries competed with each other, seeking attention for their elaborate designs.

In preparation for the assignment, we talk about photographers who work with portraiture, and I share their work with the class. Ultimately, any kind of inspiration could be beneficial to one's decision-making process.

In class, we brainstorm about what a human alphabet could encompass. The criterion for this assignment is simple: the students must represent the alphabet with direct or indirect human participation. For example, an upright, full-length portrait can represent the letter "I." The same letter could be represented with a bed sheet showing vertical wrinkles, the trace of human presence.

The options for a solution are endless. Sometimes a unique concept can answer the assignment successfully, but a simple concept can be sufficient if the student pays attention to good form and superior execution. If necessary, I allow the students to pair up into teams of four or fewer.

From a pedagogical point of view, I believe that it is my responsibility to inform students' critical awareness and equip them with the necessary tools so that they can develop their own visual voices.

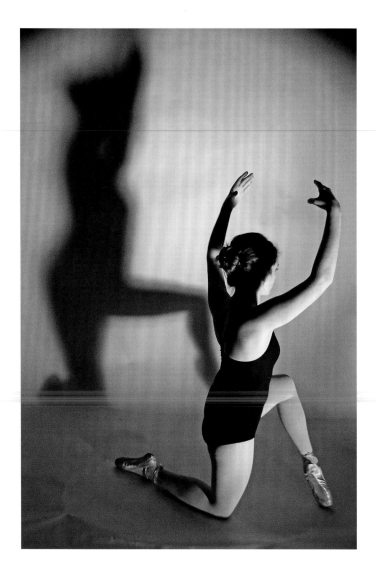

Kristen Biddison
Form and Communication, 2000s

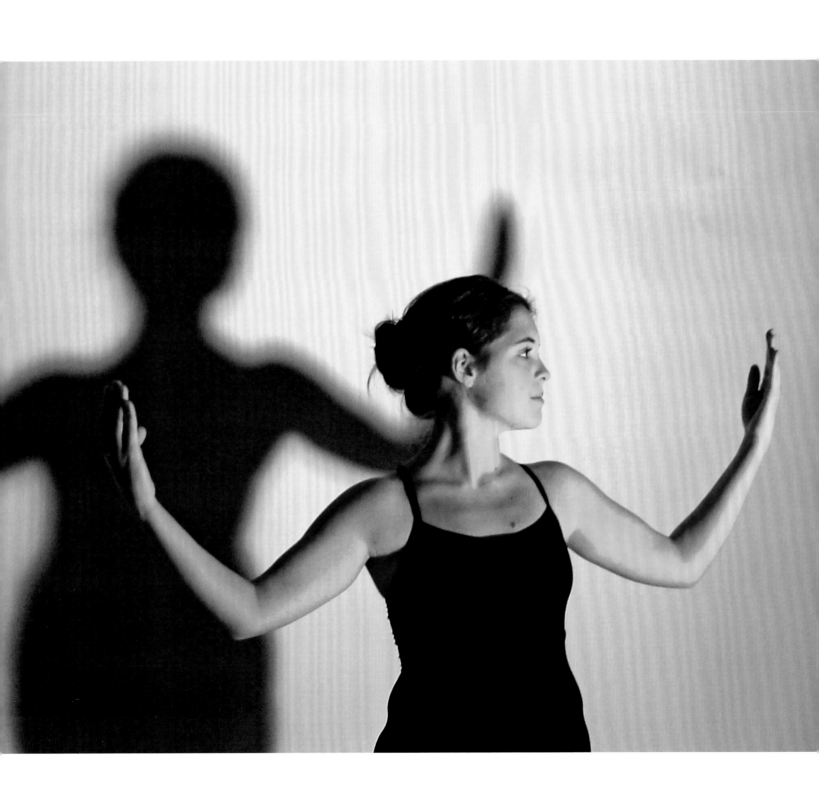

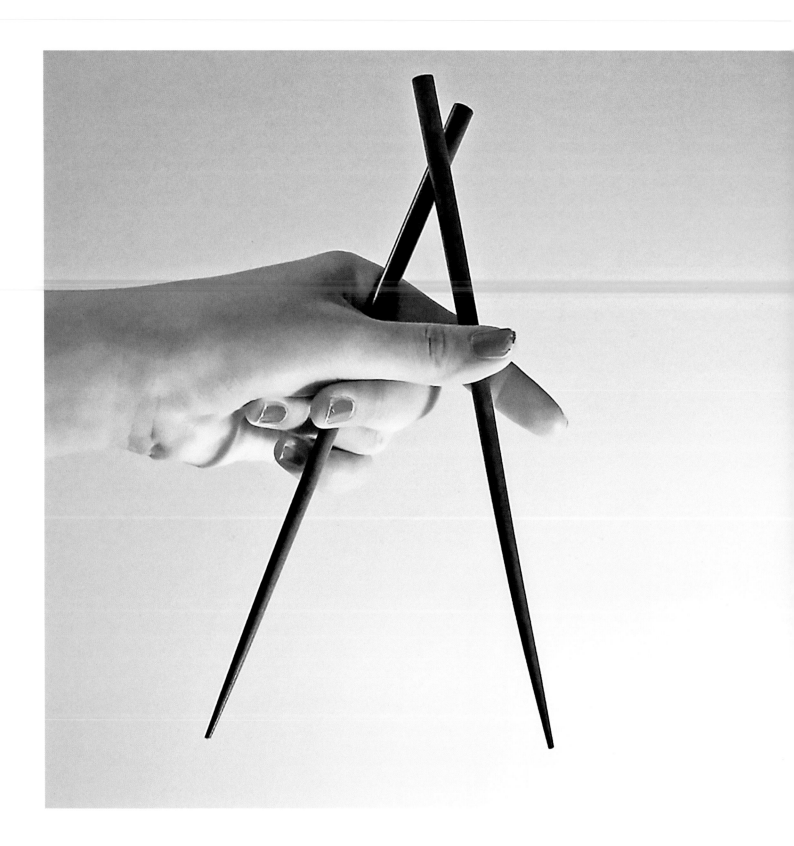

Yejin Whang
Christina Yang
Form and Communication, 2008

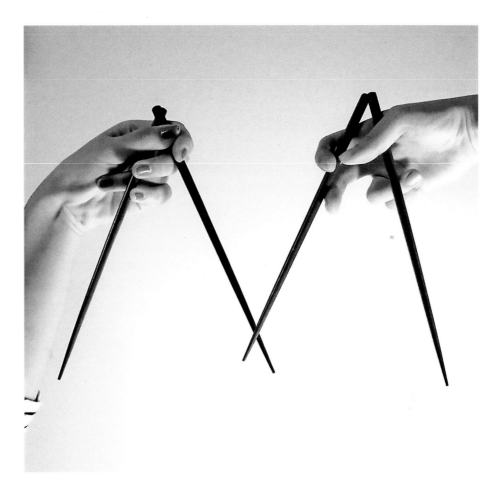

YEJIN WHANG

I had a lot of fun with this project because I got to work with a classmate and it related to my culture. We used chopsticks to show the alphabets. We used a white background, a lamp as a light source, and a camera using manual settings. The letters are in a line going down to show how a lot of the old paintings in Asia are set up.

CHRISTINA JANG

I worked with Yejin Hwang for the human alphabet assignment. We got the idea while eating sushi. Chopsticks are something we (Asians) use on a daily basis. They are used to grab food. We also tried to connect our idea (Asian-influenced) with the alphabets, by placing the images in a vertical row.

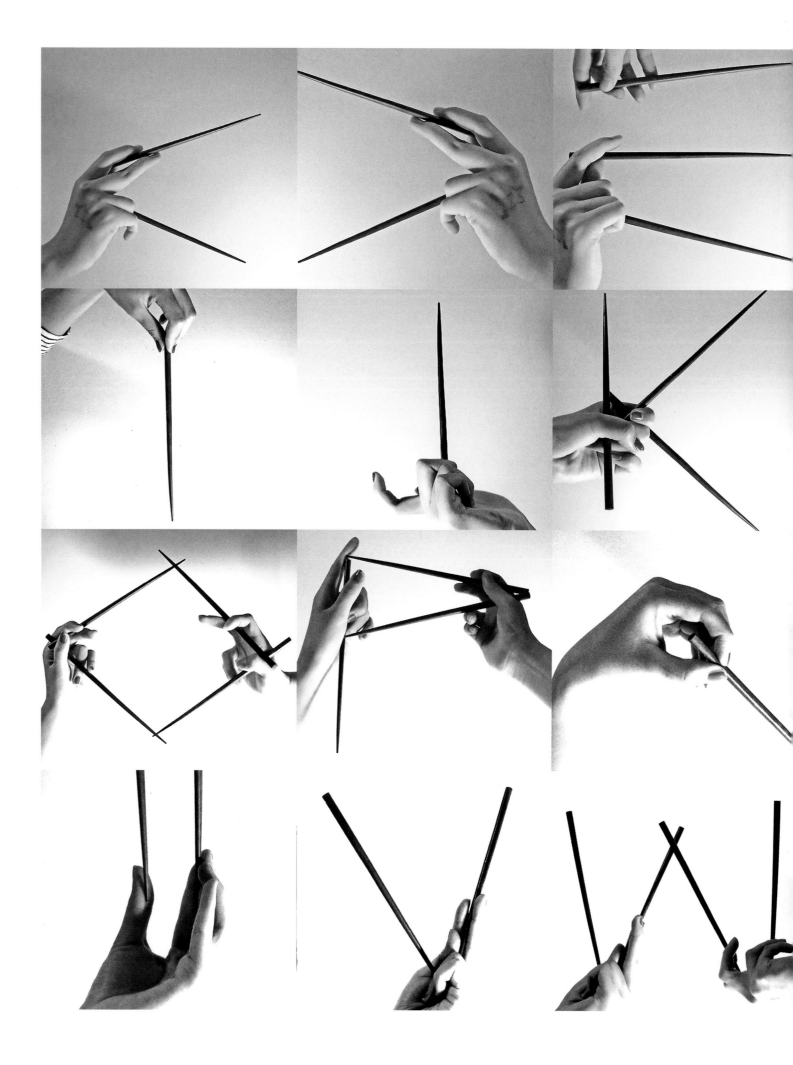

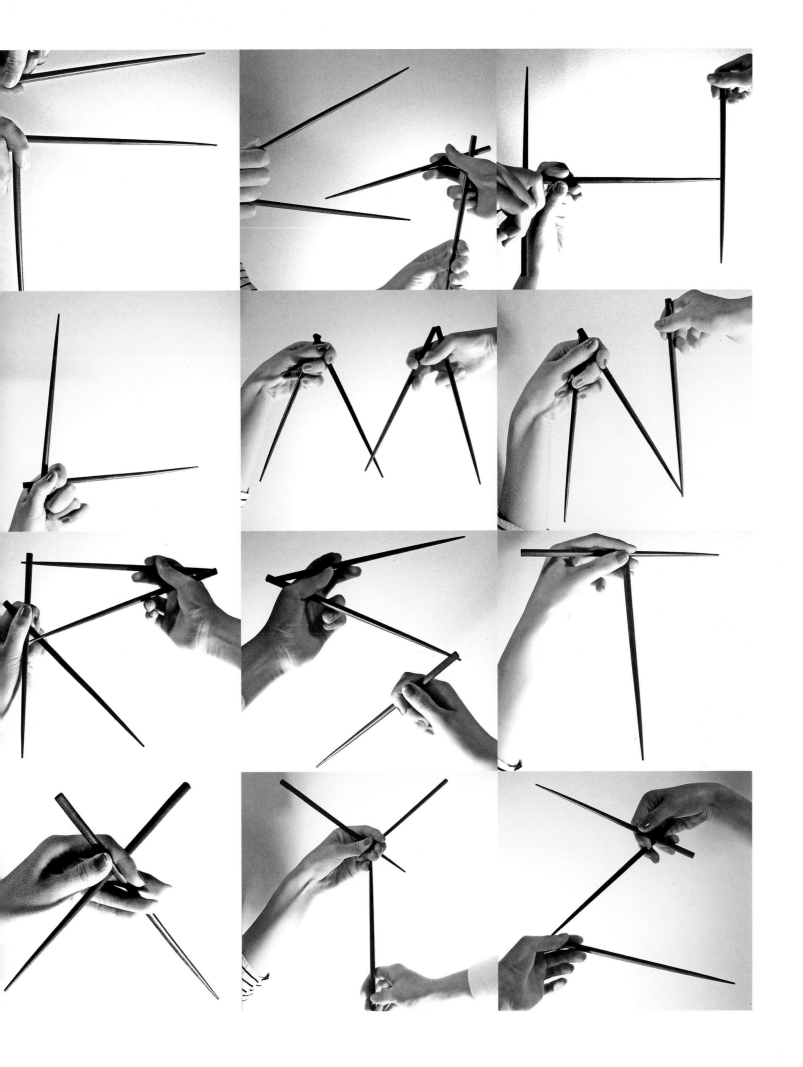

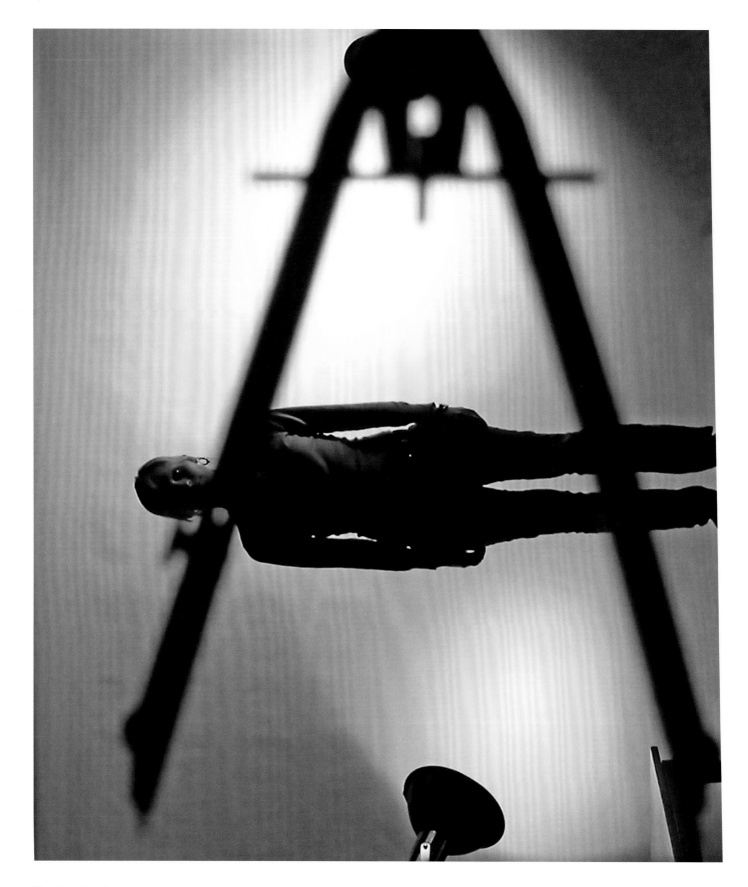

Kent Estabrook
Hillery Gronvold
Jessica McElroy
Form and Communication, 2004

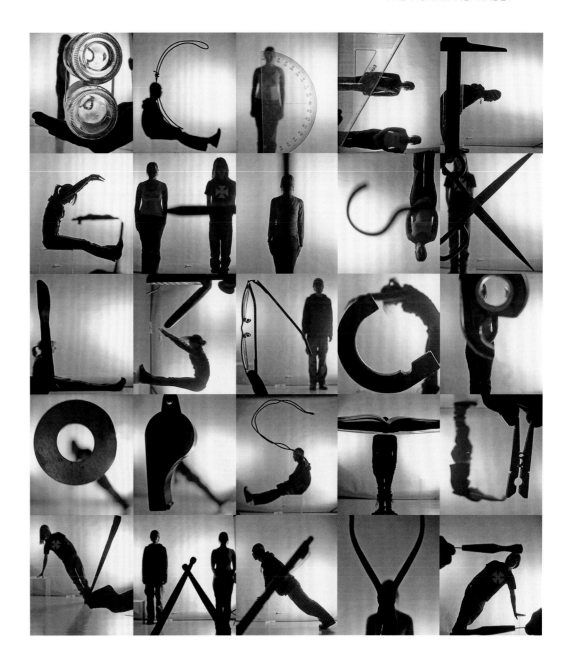

KENT ESTABROOK

This was a group effort. The original idea was Jesse's, and obviously it was a good idea, but initially lacked direction and identity. I eventually suggested the importance of maintaining a style, and not just going for letters for letter's sake. There needed to be unity between each shot. So the first question was, uppercase or lowercase? I specified that the basic difference was how much more organic lowercase letterforms were than uppercase. If we were to use organic objects such as a flower or fruit, which was Jesse's original idea, the alphabet would have to remain lowercase. I suggested that we should stick to uppercase because, not only would we be able to use more common [smaller, hand-held] objects, but the man-made forms in contrast with the organic/human form made for a second interesting contrast in addition to the initial size manipulation. That became our direction, and we each put in our two cents in choosing the objects used during the shoot. Jung and Jesse did most of the camera handling, Jung did most of the cropping and preparation, and I did the printing.

This interpretation of the human alphabet assignment is a realistic approach to the concept. It is neither a staged nor a contrived piece, but one that is well-observed and extremely well-executed.

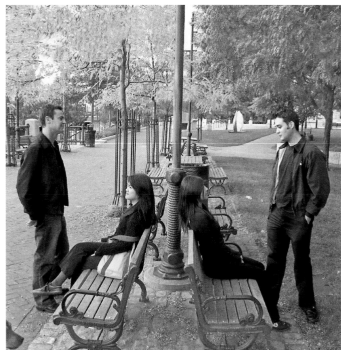

AMANDA CHEUNG

The intent of my group's alphabet project was to incorporate human letterforms with forms found in the city of Providence in order to develop the project a step beyond simple silhouettes on a background. We tried to capture a certain casualness in all the photos, as if we had simply come across people standing around the city who happened to be forming letters.

I think that the venture was a great success in terms of promoting a sensitized level of observation while all of us walked around the city each day. Because we spent large amounts of time walking around as a group and developing each letterform, the set of photos turned out to be a very clear and cohesive whole.

Personally, I think the project made me aware of the variety of forms throughout Providence and of the value of working in a dynamic group. I found that we all were very excited by "finding" the letters in the city and this made the multiple times we went out to shoot very enjoyable. I think the more eyes we had, the better ideas we came up with for each letter, and having multiple critics allowed us to very carefully tweak each letterform.

PETER ALFANO

Our intent was to show how letterforms are present in the cityscape through the use of the human form and architectural elements. Although each shot was composed, we sought to create an uncontrived, candid appearance. Exposures were made in color on a digital point and shoot and a professional digital SLR. Next, by manipulating the channel mixer, the color file was mapped to grey scale. I sought to enhance the contrast, while maintaining the appearance of a traditional black and white photographic print.

Peter Alfano
Amanda Cheung
Steven Li
Jon O'Keefe
Dungjai Pungauthaikan
Form and Communication, 2004

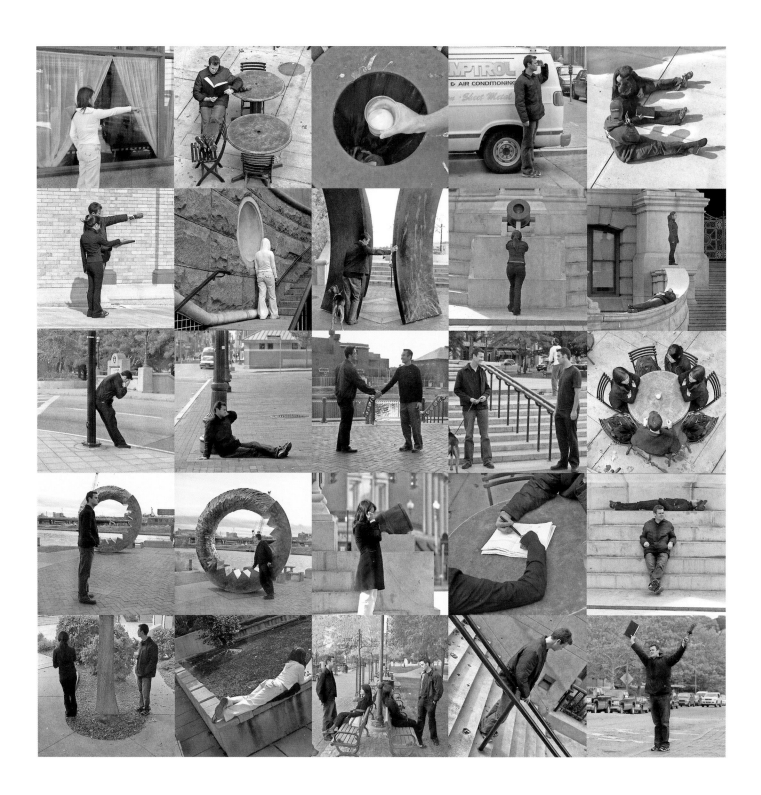

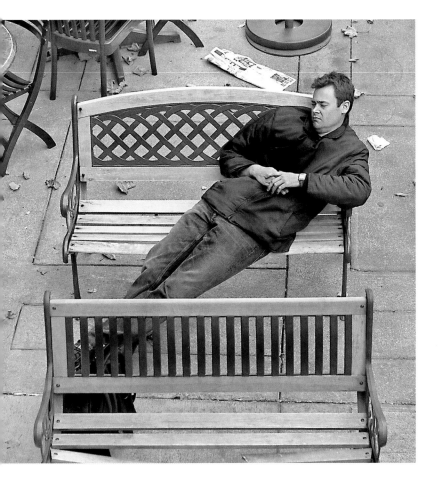

STEVEN LI

The human alphabet project was an attempt to connect the forms of the members of our group to the forms of the city. In a series of posed yet "casual" photographs, human elements were integrated with architectural elements to form the dynamic characters of the alphabet. In the process of searching for letterforms in the city, the group took on new perspectives on city and architectural forms. No longer were lamp posts and benches seen as mundane objects, but they quickly became forms that could be integrated into letters.

JON O'KEEFE

Looking at people in their city environment that form our everyday Western alphabet, our focus was to join human interaction with existing elements of man made structures. We wanted to present a casual feel of people doing what they naturally do with as little staging as possible. Our process was quite a challenge. We had to meet 5–6 times for photo shoots and more additional time to conceptualize to the project and get it to a finished state.

DUNGJAI PUNGAUTHAIKAN

With this project, our group became interested in capturing the human form and its interactions with the city. Also, how we as humans can perceive and start to extract shapes from the environment. Our goal was to capture a sense of casualness as we walked and simply observed the city.

Gabriela Alford
Esther Chak
Crissy Cowhey
Form and Communication, 2004

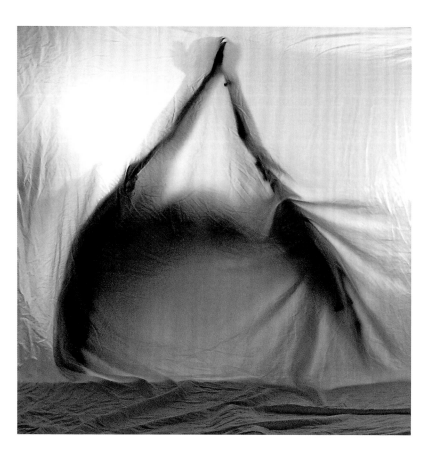

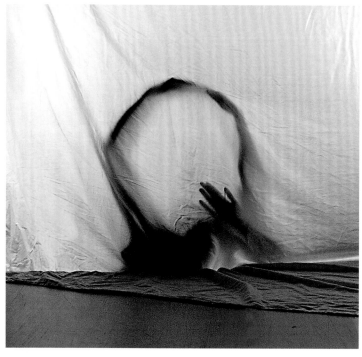

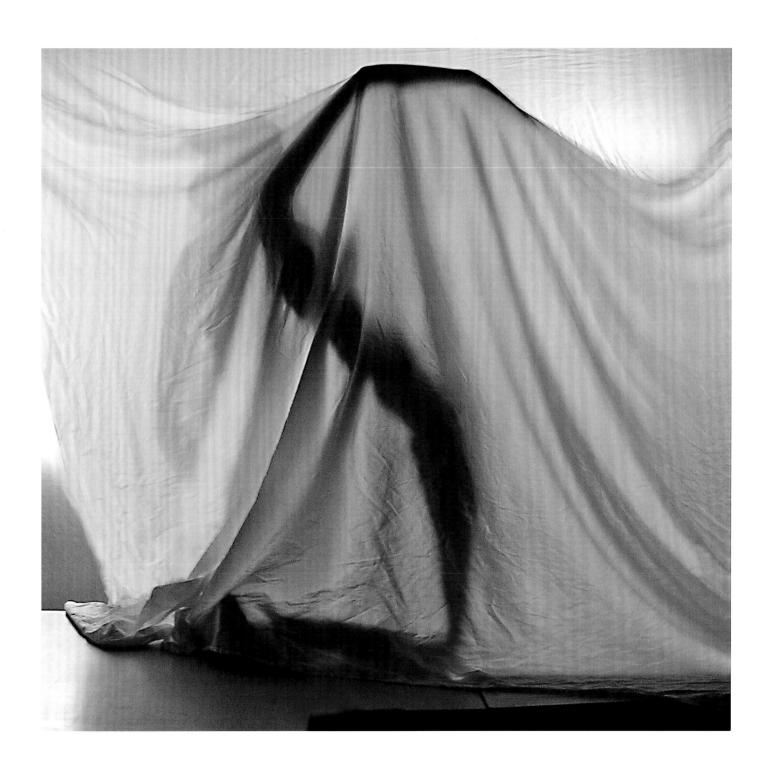

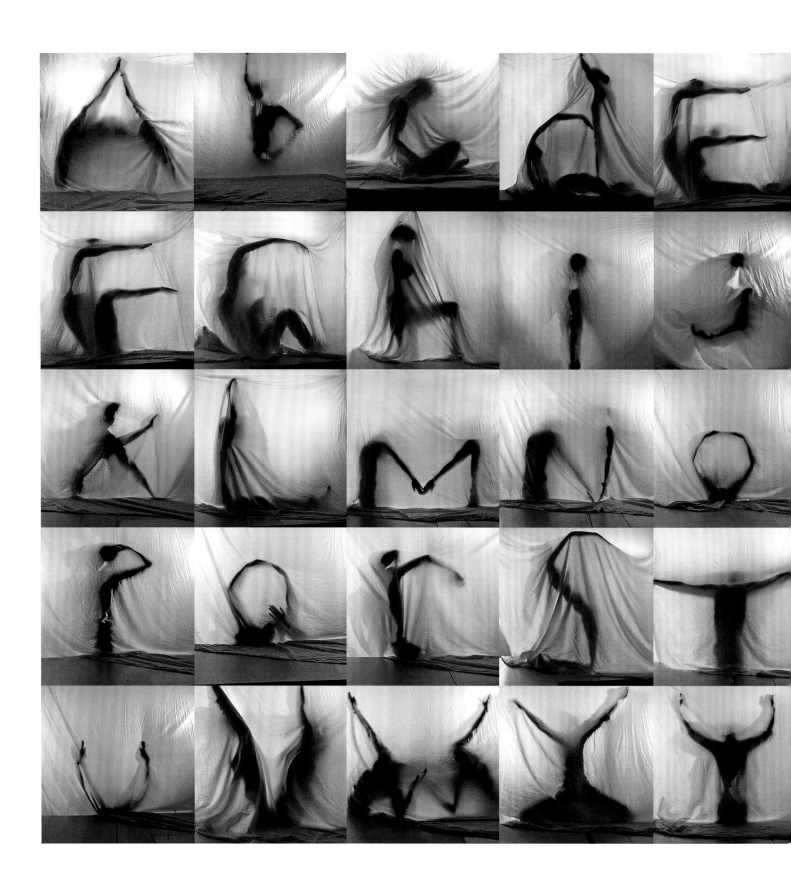

ESTHER CHAK

Collaborating with classmates Gabriela Alford and Crissy Cowhey, we created an alphabet out of human forms and focused on the notions of skin and corpo-reality when representing the body. Using a sheer white bed sheet and hot lights we were able to achieve a glow-ing and wrapping effect when including human forms into the setup. We shined lights from both the left and the right, which were placed behind the sheet.

The models posed, strategically pressing against the fabric, to achieve the desired forms and effects. Two of the most surprising and visually pleasing discoveries we made were the glow of the human skin again the sheet, which gave the compositions a depth that they would otherwise have lost as mere shadows on white paper, and the perceived motion lines of the wrapping and twisting of the fabric.

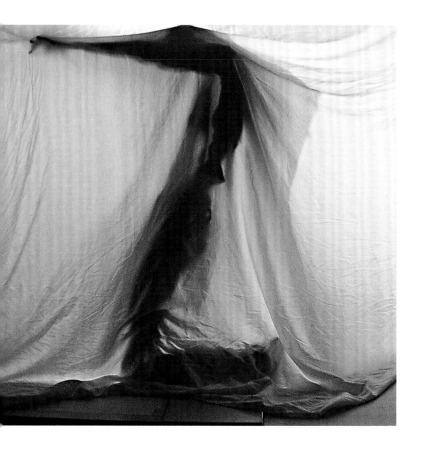

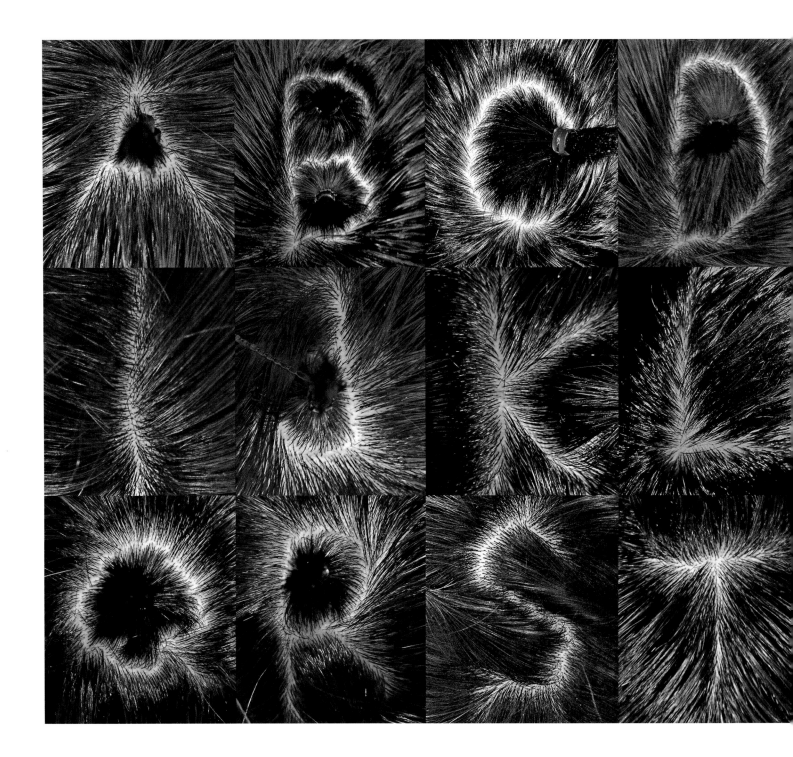

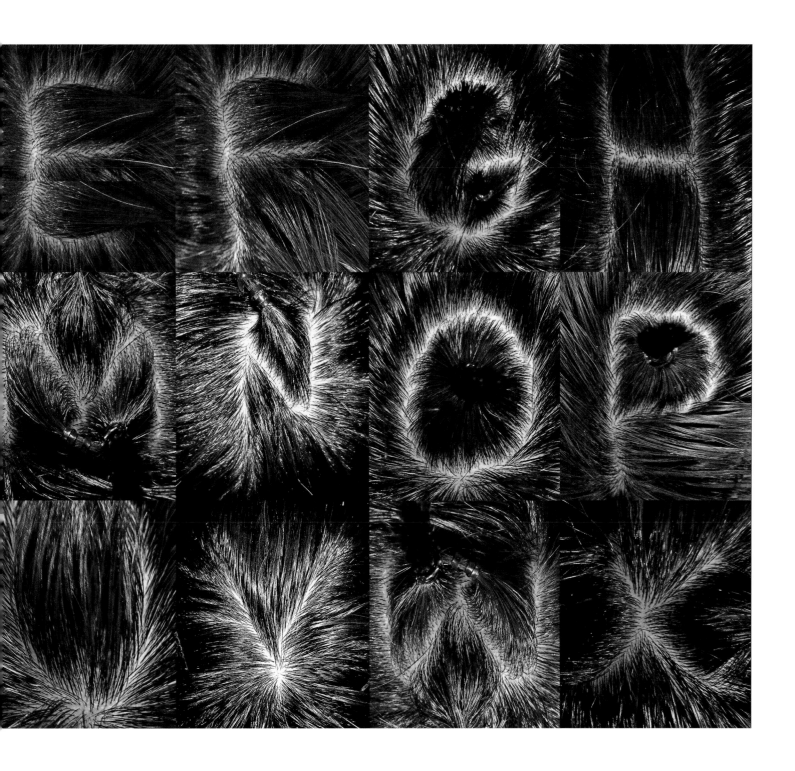

Hannah Kim
Form and Communication, 2006

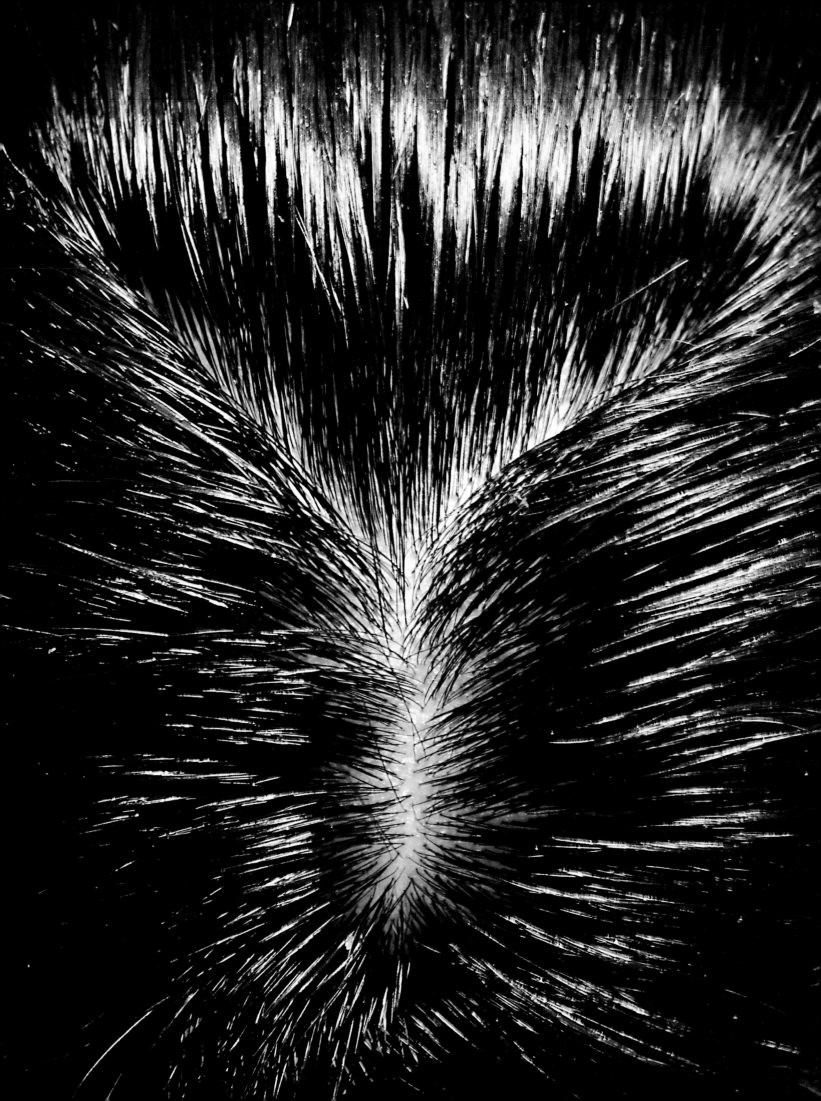

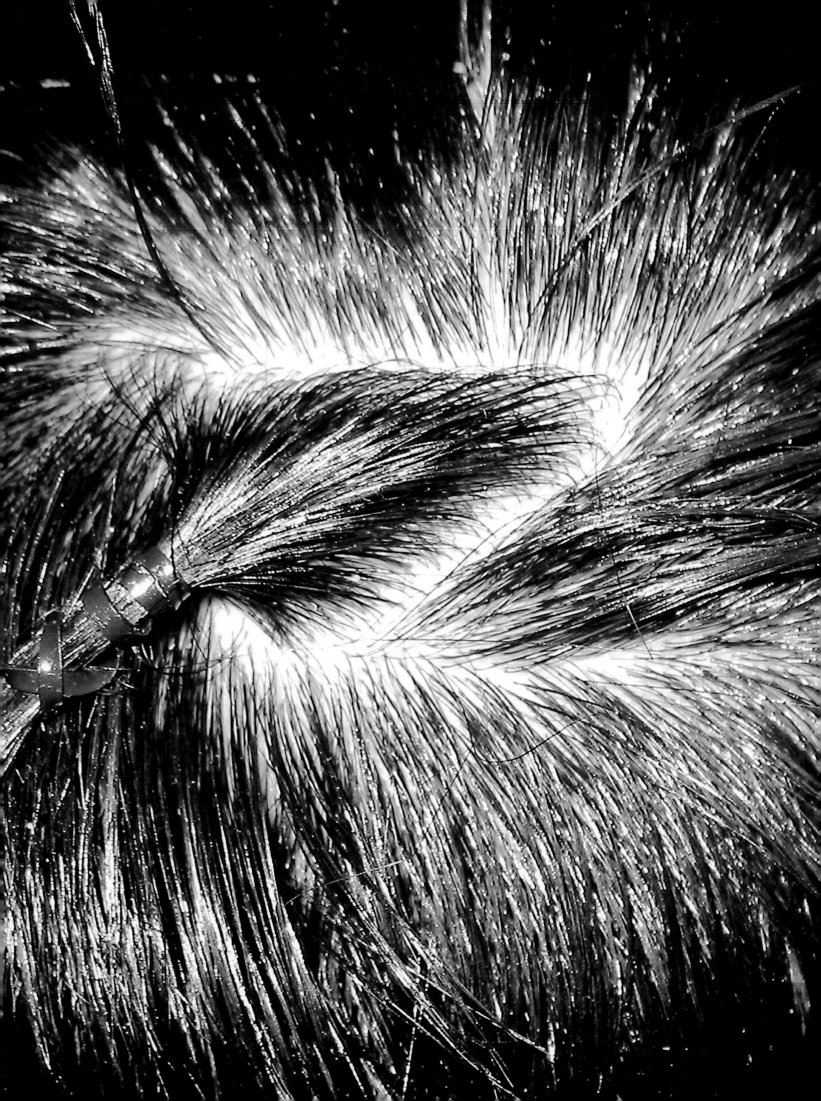

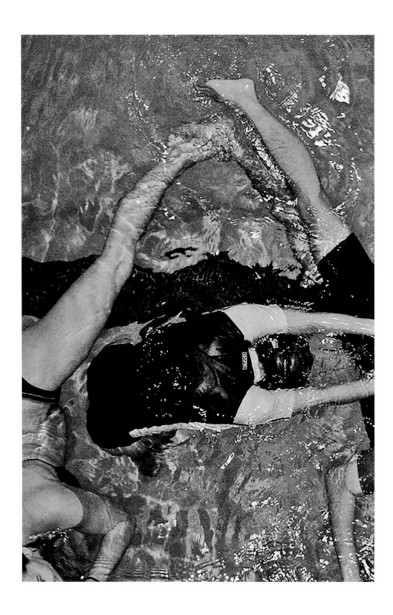

Claire Holroyed
Liz Mikulskis
Adrienne Yang
Form and Communication, 2004

CLAIRE HOLROYED

I formed a group with Adrienne Yang and Liz Mikulskis. Liz suggested we go to the Brown pool and create letters in the style of synchronized swimming. We dragged Adrienne's husband along to help with the letters. It was difficult for the swimmers because they had to strike a pose and tread water at the same time. For some of the poses, they stuck a foot out onto the side of the pool to steady themselves and keep from floating out of the letter shape.

LIZ MIKULSKIS

Claire, Adrienne and I tried to use the human form while floating in water. We felt that the ability to float and have less of a sense of gravity would help us in forming letters. The pool gave us a nice atmosphere with the water ripples the distortion of the human figure under water and the lane lines at the very bottom of the pool.

ADRIENNE YANG

This project was a group effort between Liz, Claire and I. We decided to "perform" our alphabet in the swimming pool to see what interesting results may arise. Before arriving at the pool, I had rough sketches of our alphabet. My sketches were based on our bodies in the water, using the two lane divides as the horizontal part (or stem) of the letters. However when I got to the pool, I found out we could only use the outside lanes (or one lane divider), so we improvised. It was more difficult than being in a lighting studio and on solid ground. As a result, we saw our letters from a different perspective, an aerial view, and because we were slightly under water, parts of our letters were distorted.

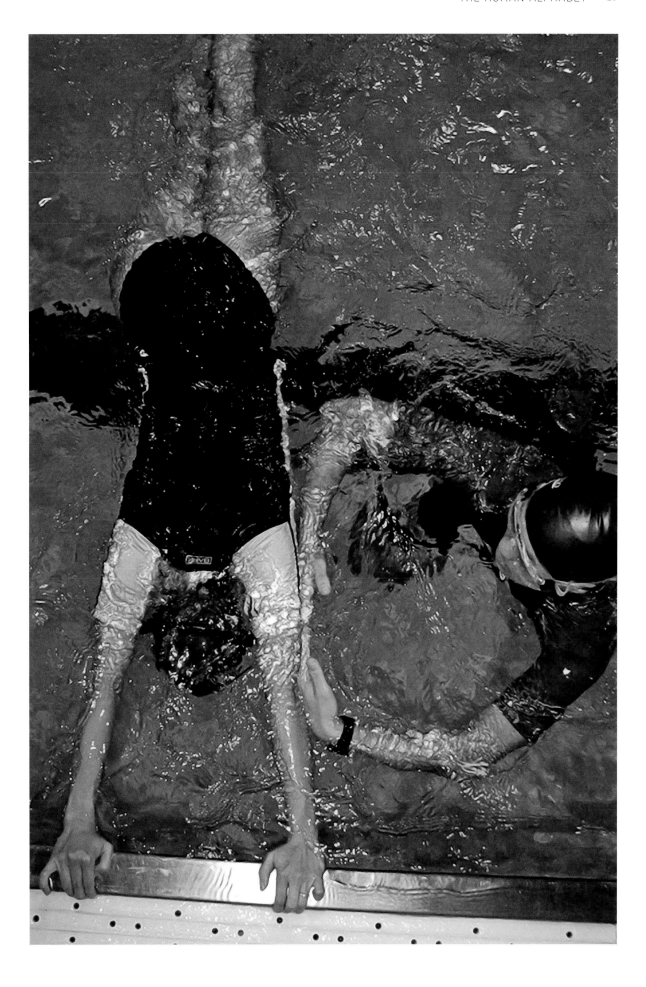

Many sports, such as swimming, lend themselves perfectly for the project because they involve the manipulation of the human body.

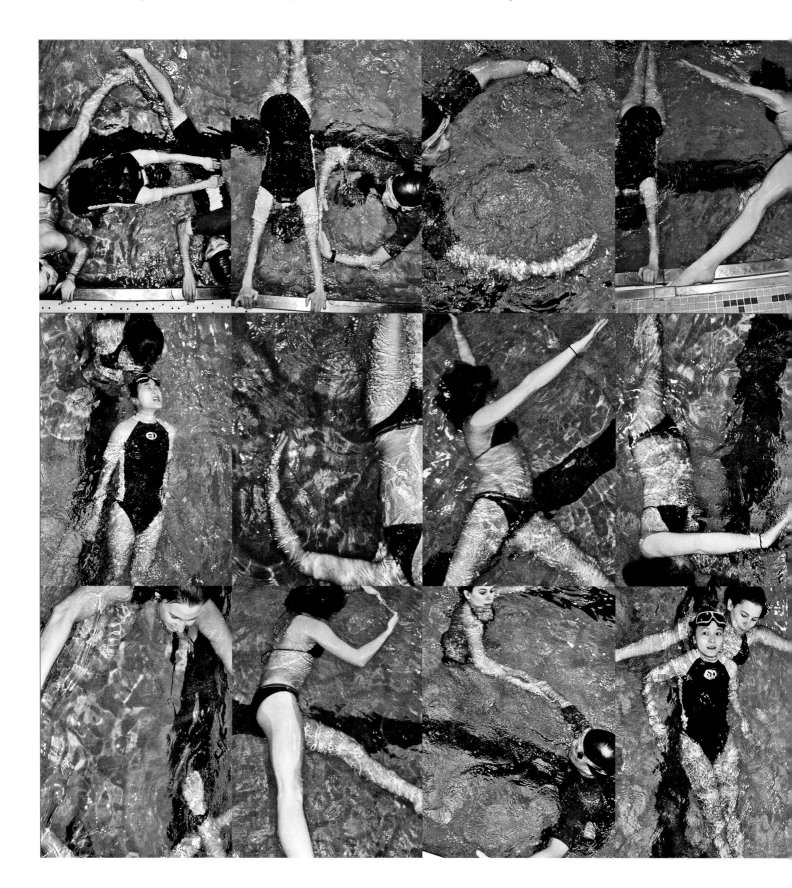

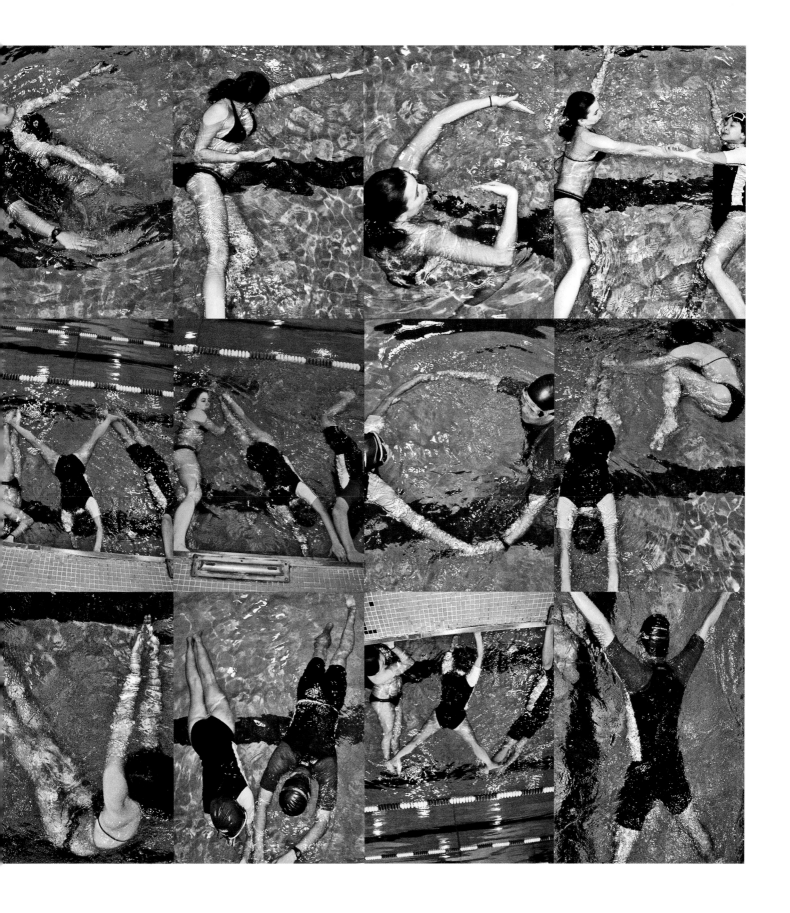

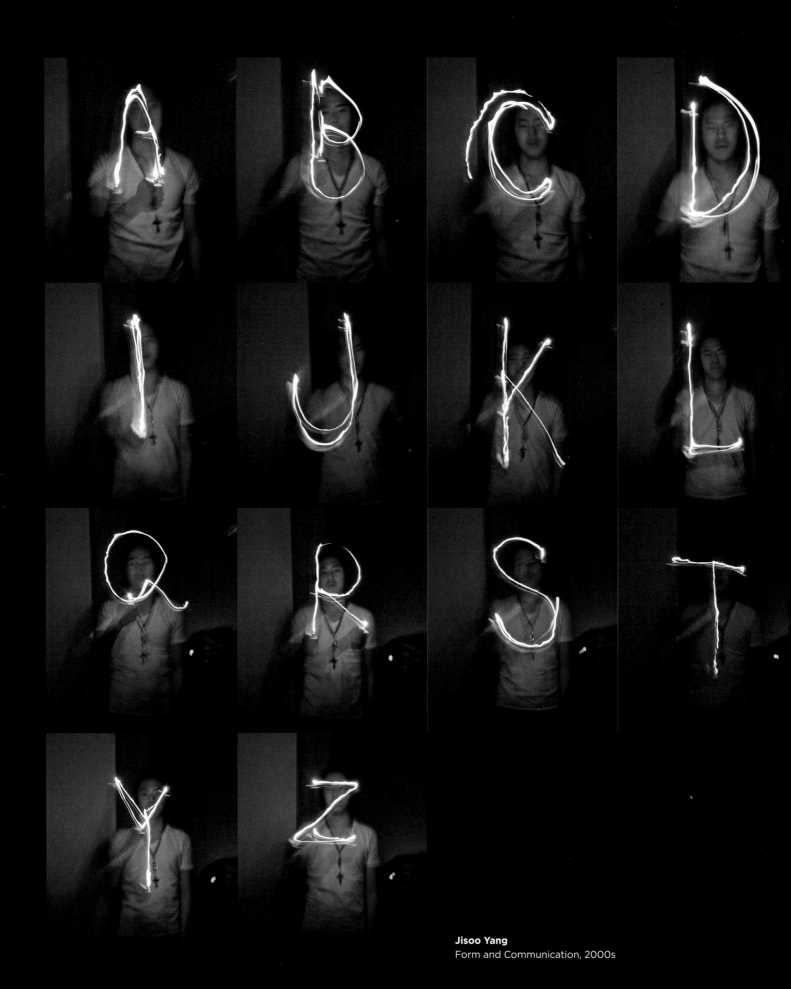

Jisoo Yang
Form and Communication, 2000s

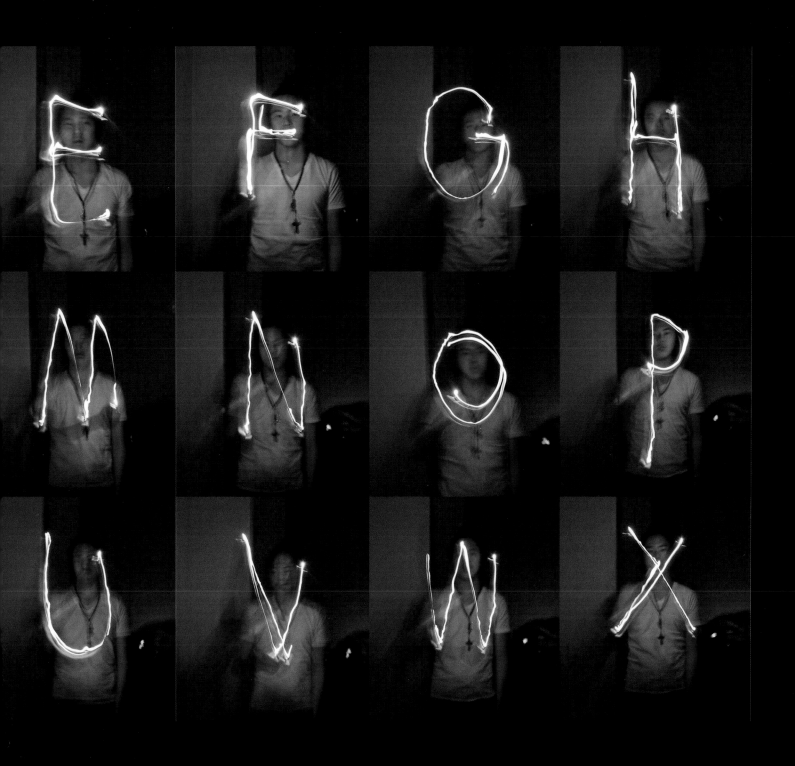

When a camera's shutter speed is slowed, one can
achieve a result similar to the one seen above.
Normally, these shapes remain unseen to the naked eye.

THE CONFORMIST

I think *The Conformist* is a great inspiration for the students. The film was made in 1970 and directed by Bernardo Bertolucci. In the United States, the film was broadcast on PBS in the late '80s, but I recall having seen it earlier in Europe. I decided to tape the PBS screening. Some years later I taught a time-based course. It had a generic course title because it was at the beginning of digital media in our department. At the time, the full-time faculty in Graphic Design decided not to teach software in particular, but to focus on content. Instead, we offered software workshops and teaching assistants helped with software queries. *The Conformist* was a perfect choice for content. This movie has a tremendous amount of "ammunition" to spark anyone's creativity. One of my assignments for my new time-based course was to design the film credits for *The Conformist*. Although the film industry does not place much emphasis on the appearance of film credits, graphic designers think that words in motion are "angel food"! Since the introduction of software like Flash, Adobe After Effects, Final Cut Pro, and even perhaps iMovie, graphic designers have been able to invade a territory that was reserved for filmmakers for years.

I screened the film for the students, and the project took off like a rocket. They loved it— the movie is incredible! It is a film that offers a wide spectrum of thought-provoking qualities. From the script to the acting, the cinematography, and the integration of facts and fiction, there is something for everyone to enjoy. In addition to design challenges the students confront in this assignment, they also learn something important about world history from the film.

I decided to expand the assignment. In addition to the creation of film titles, the new project consisted of a visual narrative. I asked the students to present the movie in ten still pictures. In order to make this project more challenging, I added limitations: students had to use old-fashioned glass mounts used for 35mm transparency.

I explained to my students that these glass mounts were the canvas that they had to use to tell their stories, impressions, and feelings about the movie. They could use different tools and/ or materials to apply to the glass mounts, which consisted of two sides that snapped together, allowing them to sandwich soft materials between the sheets of glass. No two students ever have the same results with this assignment.

After completing the treatment of their slide mounts, they scanned them using a flatbed scanner. Then, they had to arrange them in a meaningful order. It is this sequence that indicates a particular rhythm, direction, and tempo. What results is a new kind of storyboard, visualizing all sorts of aspects of this movie. Usually color choice is considered subjective, but in this assignment it turns out just to be the opposite. The movie doesn't use a palette of bright colors but sort of follows the color scheme of Art Deco. Some students depict their impressions about the movie more figuratively, others more abstractly. The outcome of this assignment is always fascinating.

As a teacher, I learned a great deal with this assignment. It is essential to select quality content as a source for the students. Whether it is a book, a movie, or music, the instructor should always choose source material that will engage the stu-dents intellectually and aesthetically. Good quality is timeless. This is why my students still enjoyed a movie made in the '70s with content from the '30s. Also, the selection of medium, tools, materials, and software determines not only the outcome of the assignment, but also equips the students with the skills and confidence to visually communicate successfully. The students learn how to research, assemble a storyboard, edit, create images, and, most importantly, how to face the challenge of scale—the tiny canvas.

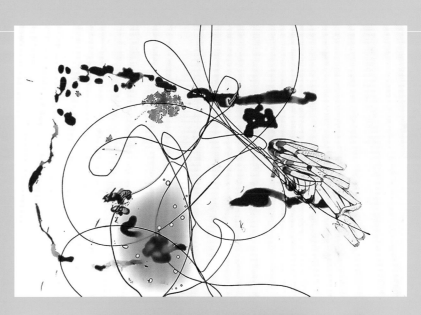

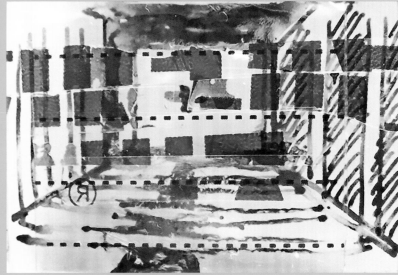

Anna Kim
Form and Communication, 2005

Christine Tian
Form and Communication, 2006

A.

B.

C.

D.

E.

The Process

A. Use a double-sided glass slide mount

B. Separate the two sides of the glass slide mount

C. Place pencil shavings or any small amounts of soft materials onto one side of the slide

D. You can paint or mark the glass surface

E. Snap the two sides of the glass mount together, but make sure that no bulky or sharp materials are enclosed, or the glass will break

F. The glass mount is now ready to be scanned with a flatbed scanner

G. In order to achieve the best reproduction quality, experiment with the setting of the scanning software

H. For best results, save the scan in Adobe Photoshop as a TIF

F.

G.

H.

OPPOSITE
Sarah Lambe
Form and Communication, 2000s

Materials and equipment

• 10 glass slide mounts
 (preferably GEPE)
• choice of markers, paint,
 ink, organic or synthetic materials, etc.
• flatbed scanner
• computer

Erica Nishizato
Form and Communication, 2004

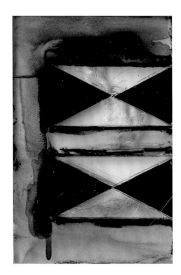

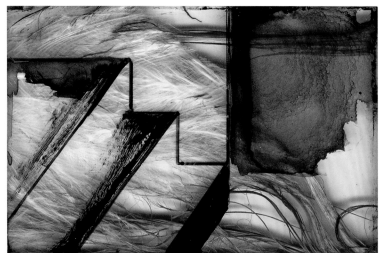

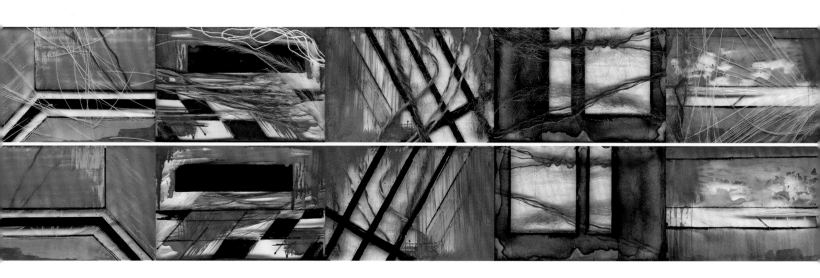

ERICA NISHIZATO

I knew little about the movie *The Conformist* prior to watching it in class, so I decided to approach this project by recording any aspect that immediately caught my attention.

The first was the flashing red and black image of the main character in his hotel room during the credits in the opening scene. I decided to use colors as a running theme throughout my set of slide mounts (red and black becoming prominent).

The second thing I found most striking was the strong camera angle that framed the scenes in relationship to the architecture. At many points, the architecture almost became flat lines and grids. I sketched the basic outlines of these scenes in small frames in my notebook, and they became the framework for my images. I later drew these lines onto the slide mounts and then painted on them with black, white and red gouache, using varying amounts water to achieve a varied effect. In some areas the paint is completely opaque and sharp, while in others it is watery and translucent.

The third part of the movie that I found intriguing was the clothing of characters. I picked out prominent colors and included bits of yarn gathered from the textile department. The colors I used were black and white (which was found throughout, but particularly in the wife's dress as we first meet her character), pink and black (in her dress at the Chinese restaurant and dance hall), and white (when they visit the father in the asylum). My favorite piece was her shirt in the final scene, which had multicolored and black vertical stripes (a la Missoni)—for this I included tan, red, yellow and turquoise yarns.

The final images are very different depending on how they are viewed. With a slide projector they are high contrast black and white images, while when viewed with a lens or in a computer scan, the texture, color and layering stand out. I also found that the images changed vastly when scanned from the front versus the back. Therefore, I have included a front side (Group A) and backside (Group B) set of scans for each slide.

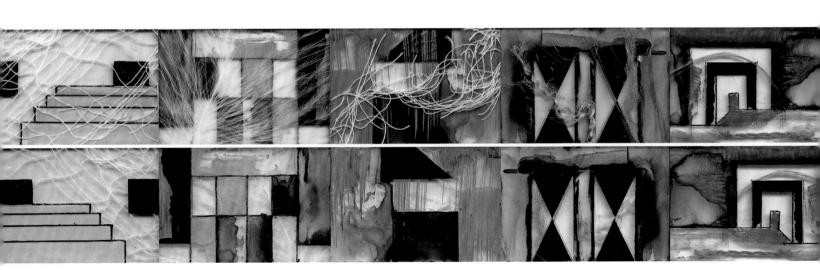

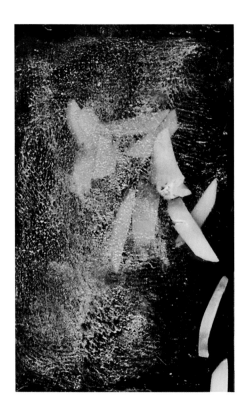
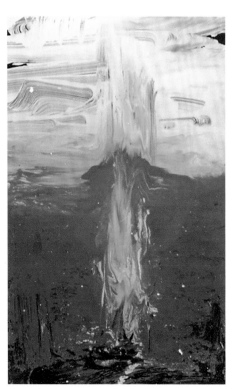

Many students who have watched the movie have been confused by its absence of color. "Did I just see a black and white or color film?" is a common question.

Esther Suh
Form and Communication, 2005

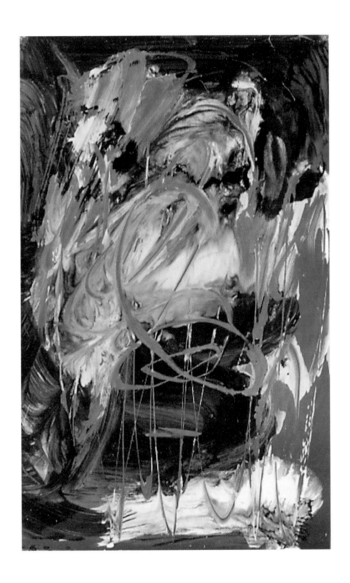

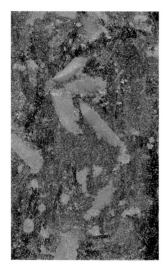

ESTHER SUH

For this assignment, we first watched the movie *The Conformist* by Bernardo Bertolucci, 1970, to get an idea for our "paintings" on the GEPE slides. The movie explores the psychology of a young man who is hired by Italian fascists to assassinate his former professor in France.

It brings up issues about sexual disorder, social decadence, and the authoritarian personality.

While I watched the film, I noticed that the movie did not have much color, but yet it evoked strong feelings and many different ideas. It seemed quiet, yet it was screaming. I mapped out events as I watched the movie to get a general idea of how it progressed in terms of beginning, middle, and end.

There were a couple of scenes that were interesting, like the murder of the professor and his wife, and the homosexual experiences. The latter one is the one that I based my slide paintings on. From this scene, I sensed innocence and purity in the beginning when the two boys were playing with and chasing each other. Then they go upstairs into a room, where the boy experiences psychotic homosexual experience and ends up killing his playmate with a gun. I portrayed the beginning scenes with light, iridescent colors to portray light, innocence, and purity. Then the paintings slowly introduce

a second element, black, to show the confusion of his own sexuality. He is introduced to a gun, and without really realizing what he is doing, he starts shooting everywhere around the room. The colors that I usually used were black and red, and some green. One of the glass slides has half black and half red to indicate confusion and to portray the good and evil side of the event.

In painting, I wanted to portray the actual murder and the feelings it evoked. I went far to describe the feeling that I got from it by scraping and painting with black and reds. I used ink, gouache, and eraser cut into tiny pieces. They were definitely different when projected to the big screen than when I was looking at them. Just like the photograms, I was amazed that such a simple process could produce such a beautiful work just as good as when you paint on a canvas with big brushes. I can see myself applying these techniques to just about anything in graphic design. The act of looking back at all three assignments has helped me review these processes and realize everything that I learned from them without even realizing.

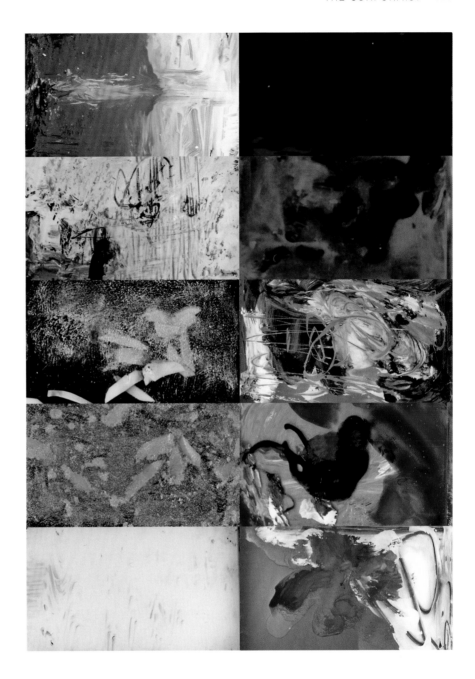

In this particular work, I observe influences from Asian art
or maybe even a touch of Claude Monet.

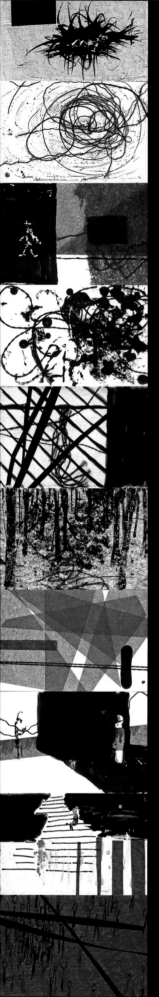

LESLEY WANG

For this project, my desire was to create slides of the emotions I felt when watching the movie, as well as the emotion evoked within certain scenes of the movie.

Many of the slides are abstracted scenes from the movie where I have integrated a mark or texture that I feel describes the emotions felt during the movie. For example, slide 04 is a direct scene from the movie: it takes place near the end of the movie before the main character is about to leave to see his friend. He talks to his wife. He is draped in shadows while she stands in the light. They are separated by a dark hallway. This scene stood out the most in my mind. My slanted red tracing paper slices across both figures connecting them, but also shows their distance from each other.

I used sumi ink, markers, plastic, tracing paper, string, etching, lip gloss, glue, cut out shapes, tea, and tea bag to create these glass slide mounts.

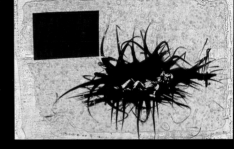

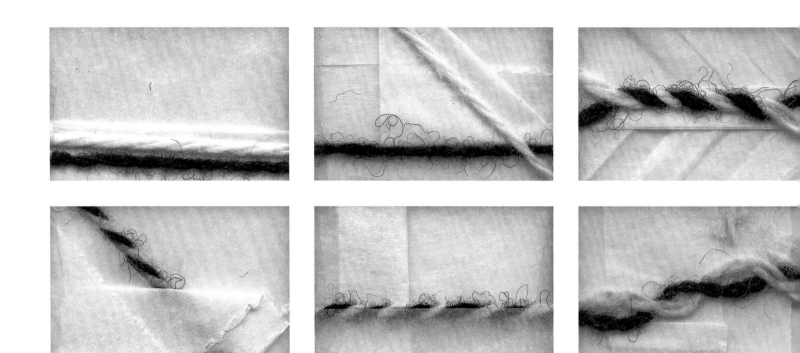

Jonathan Chung
Form and Communication, 2008

JONATHAN CHUNG

After watching *The Conformist*, one of the most remarkable features that remained on my mind was the structured setting. Although the movie made good use of color, there was so much contrast and nuance that it felt like the film was in black and white. I reflected on on these unique features and folded tracing papers to create geometric and structured forms.

By folding and overlapping the transparent paper, I was able to get a range of white and light grays to work with. The strings represent the relationship among the three characters, the man and the two women. I manipulated the strings in a variety of ways, such as braiding and intersecting them, to metaphorically depict the relationship. The 10th slide is blank because I thought none of the relationships are completely resolved in the end.

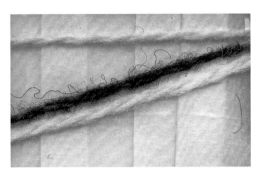

I truly enjoy the concept of tying knots, since each can
be used to represent something far more complex
than the fastenings made by two pieces of string or rope.

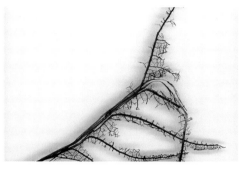

Jessie Rauch
Form and Communication, 2008

JESSIE RAUCH

The Conformist was a powerful movie with very specific imagery. I felt that it would be too much to try to distill the whole movie into ten slides, so I decided to focus on a single concept: Marcello's struggle for a perfect normal life, and how it eventually destroys him.

Marcello is represented by a thin, skeletal leaf, which decomposes over time. The perfect leaf in the first slide is still transparent and frail, much like the reality that Marcello has created for himself.

The black veins of the leaf echo the imagery of the iron bars that appear throughout the movie. As Marcello betrays his friends, mentor, and lover, and then betrays everything he thought he stood for, the leaf crumbles, until by the last slide there is only a broken reminder of what once was there.

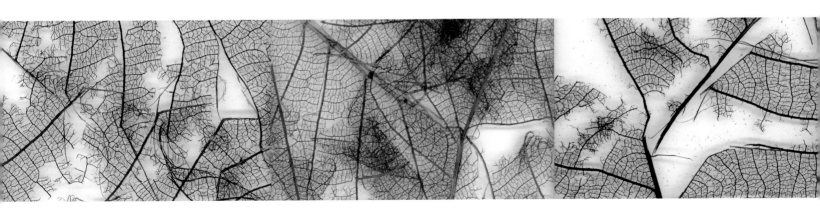

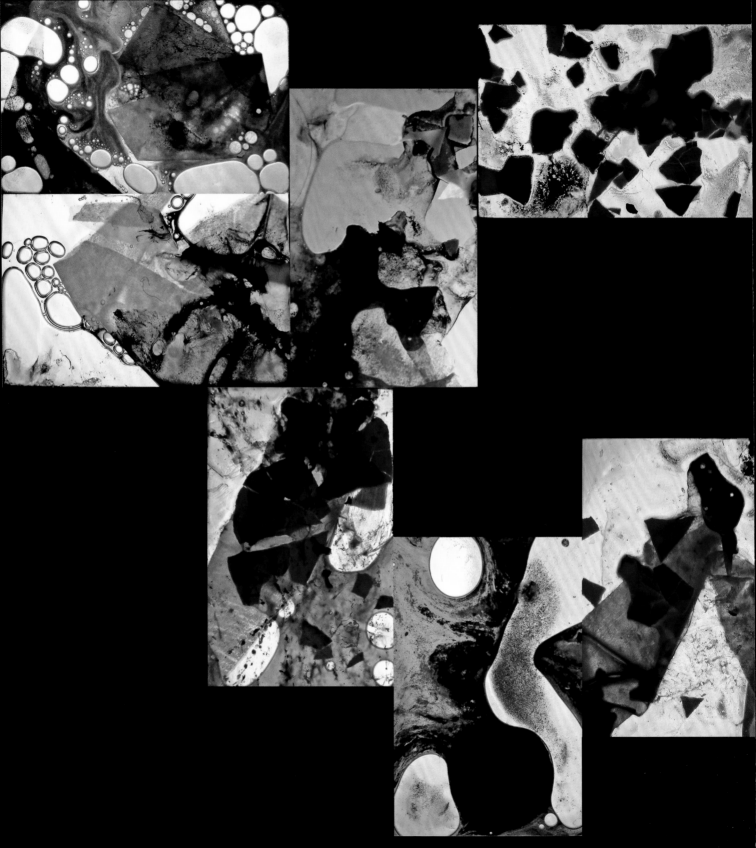

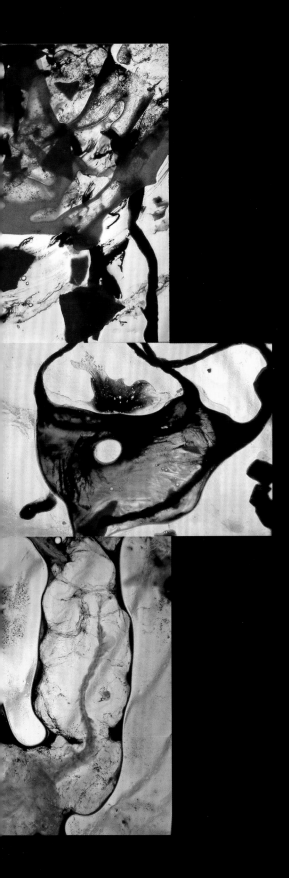

So Young Song
Form and Communication, 2008

SO YOUNG SONG

After watching the movie *The Conformist*, I felt that
all human beings are weak. Marcello, the main charac-
ter, lost his identity when he was young, and he is
continuously relying on others such as an engaged
woman, his previous professor's wife, and Fascism.
Finally, Marcello becomes a Fascist, and he gets mad
when the Fascists fall from power. He completely
loses his life because of this.

I tried to express this weak person through an egg
because an egg is easy to break, just like Marcello. I
put all of the elements in the egg such as the umbilical
cord, yolk, egg white and eggshell. Also, I put black
and red ink to depict the dark atmosphere of the movie
and the theme of death. When I arranged my work,
I connected lines so that it looks like a human blood
vessel. Following the arrangement, at the end, this
blood vessel is changed to broken eggshell, which
implies the weakness of Marcello.

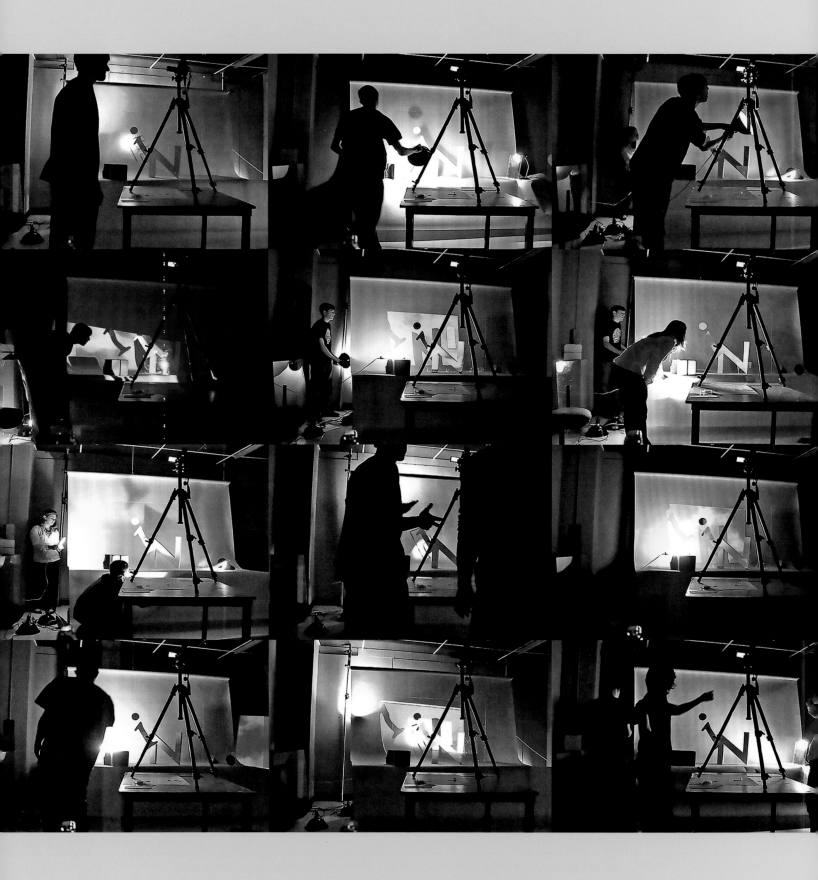

VIDEO/GRAPHICS

One of my most formative experiences with film was during my postgraduate studies at the School of Design Basel. I signed up for an elective class with professor Peter Olpe and became very passionate about the medium. I continued my film studies with professor Peter von Arx. It was because of these experiences that I later began to teach several film-related courses myself. The classes I attended at the School of Design were structured in a way that dealt specifically with the phenomenon of moving images, more so in an optical sense than in a conceptual one. For this reason, I ask my students to analyze the material characteristics of video and convey, as video-graphers, that aspect of the medium. By compar-ing different media to film, students are more easily able to understand its intrinsic qualities. If we compare illustration to video, for example, the tools and processes are very different. If two artists were to represent a person laughing, the illustrator would have the choice of his drawing implement and paper surface. The videographer, on the other hand, would control the lighting and the motion and optics of the camera, as well as the sound of laughter. He or she could change the depth of field, focus, and zoom in order to con-trol the manner in which the subject is portrayed.

My philosophy is, no matter what medium is chosen, we as teachers have an obligation to remind our students that their time in the class-room should also be used to experiment and push beyond the limits of the medium.

One of the most successful video assign-ments I gave my students originated in my analog photography class. Its goal was to introduce the students to lighting. Their assignment was to position each letter of the French word *FIN* (*end*) on a different plane of the horizontal setup. In order for the students to take full advantage of this exercise, it was essential they use only white materials. All of the letters were cut out of white cardboard. The students mounted the *I* onto a sheet of propped-up glass, placed the *F* at an angle to the camera, and cut the letter *N* out of the white backdrop paper. The amount and direction of light determined how much of the lettering was revealed. A full tonal gamut from light to dark can be achieved through this process. The purpose of this exercise is to demonstrate that beautiful tonal nuances can be created through the use of controlled lighting.

One also experiences the illusion of motion through the use of dynamic lighting. By keeping the camera in a fixed position and moving the light source, this illusion can be achieved. At this stage in the assignment, I allowed the students to use colored lighting or digital projection.

B.

D.

E.

F.

I

N

F

C.

The Process

A. Secure camcorder

B. Low-wattage backlight will make cutout letter "N" appear very bright

C. Projector can beam light in motion

D. Roll of white backdrop paper will create seamless background, pulled across tabletop

E. Secure plexiglass with fishing line from above

F. Table is at least as wide as backdrop paper

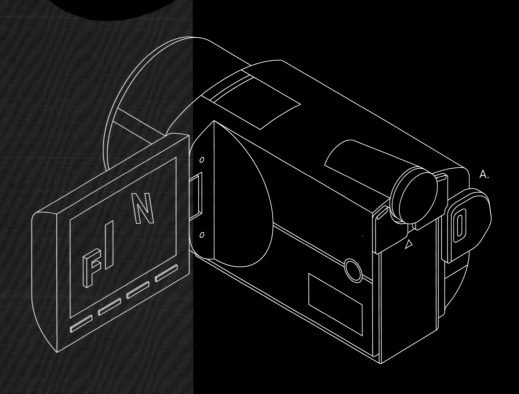

Materials and equipment

- 36"x 36" sheet of plexiglass
- roll of white backdrop paper with letter "N" cut out
- 10" tall 3-D letter "F" constructed out of white Bristol board
- 12" tall letter "I" cut out of thin white paper

- camcorder
- tripod
- adjustable stands for the backdrop paper and lights
- one or more low-wattage light sources
- digital projector
- table that is at least as wide as backdrop paper

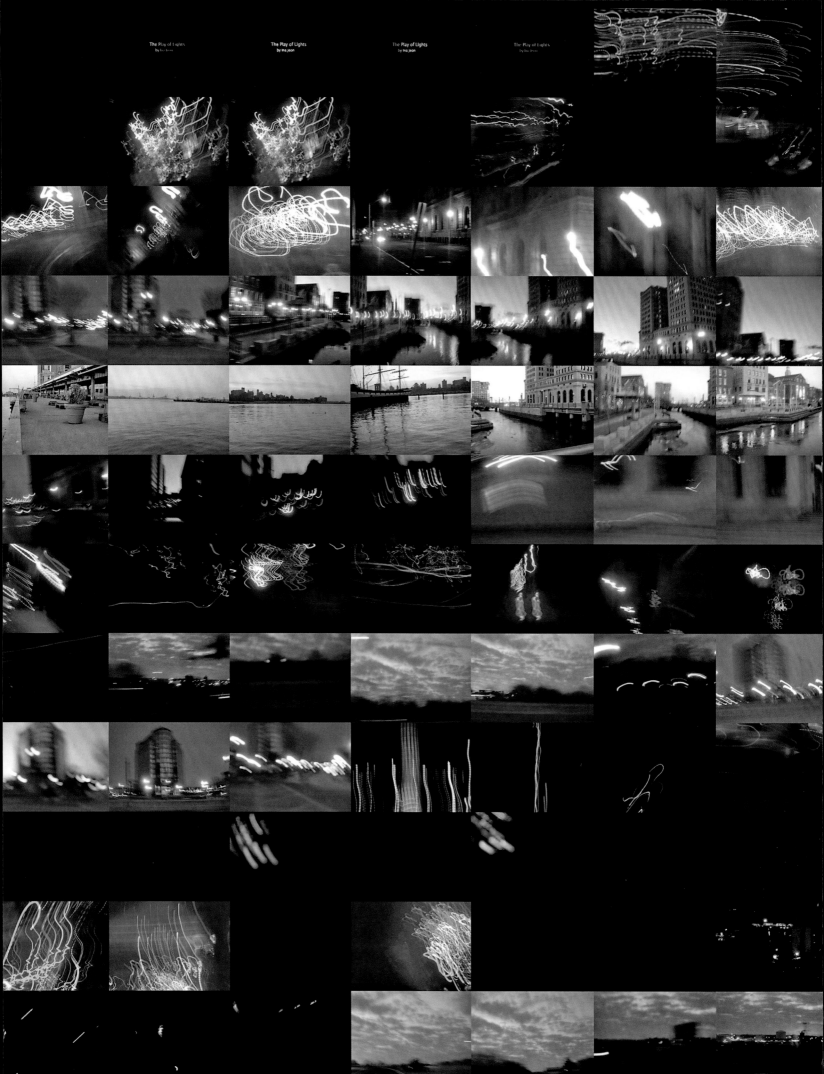

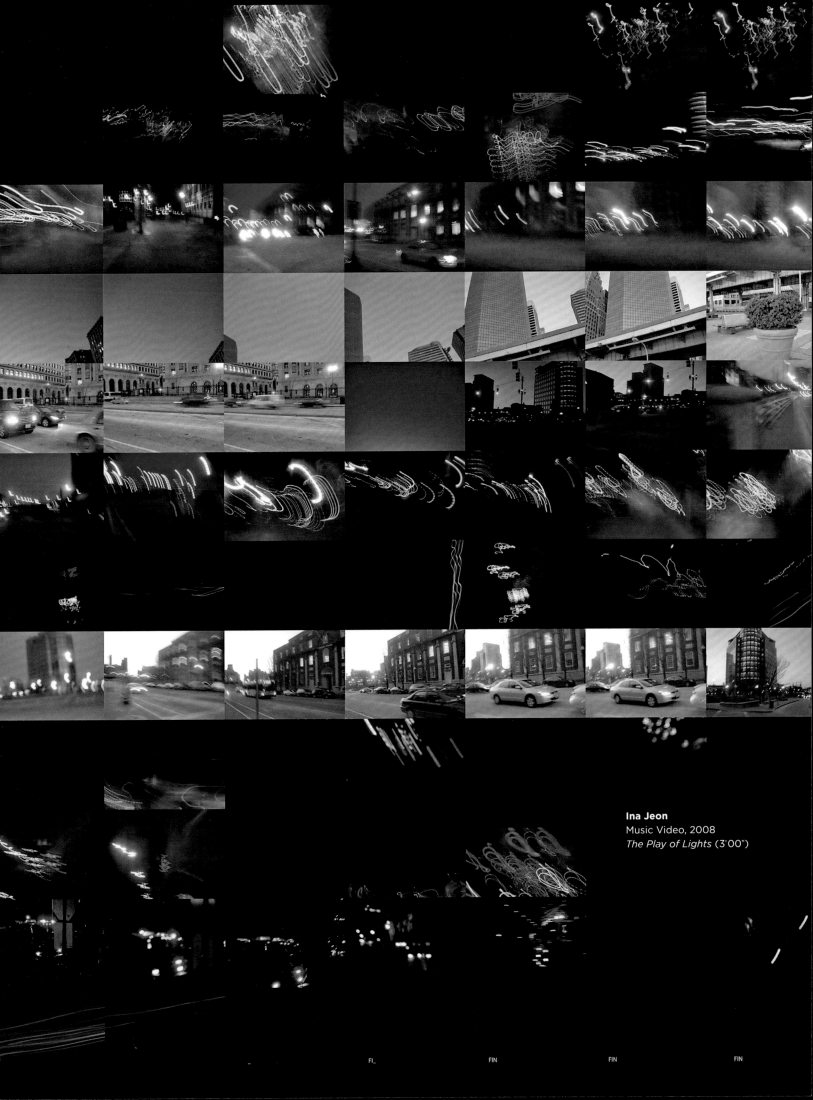

Ina Jeon
Music Video, 2008
The Play of Lights (3'00")

FI_ FIN FIN FIN

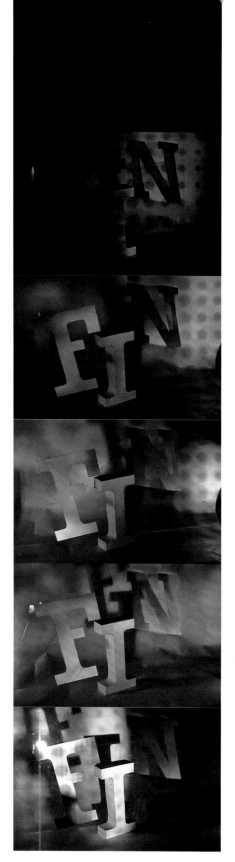

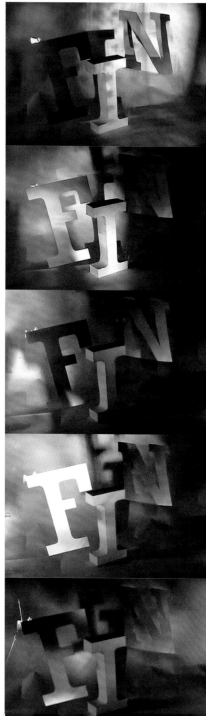

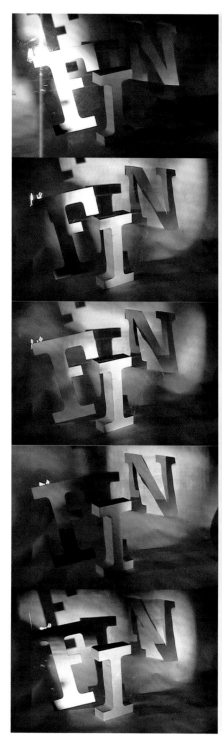

Ashley White
Photo/Video Graphics, 2006
Fin (1' 59")

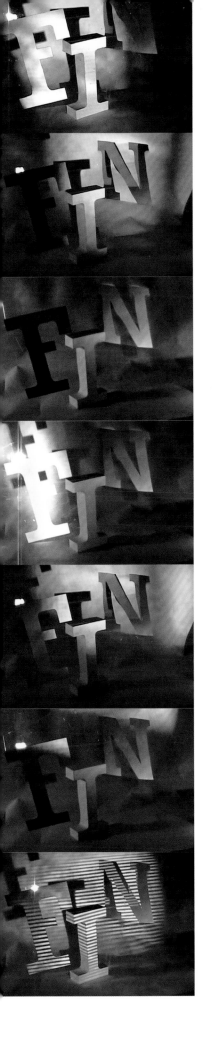

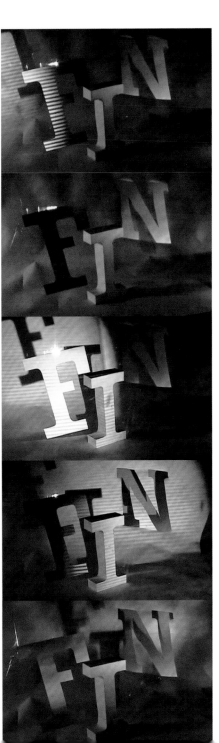

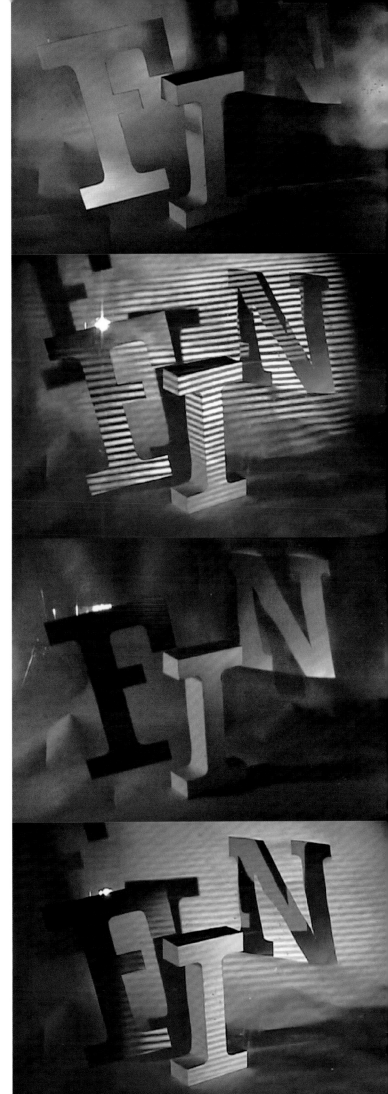

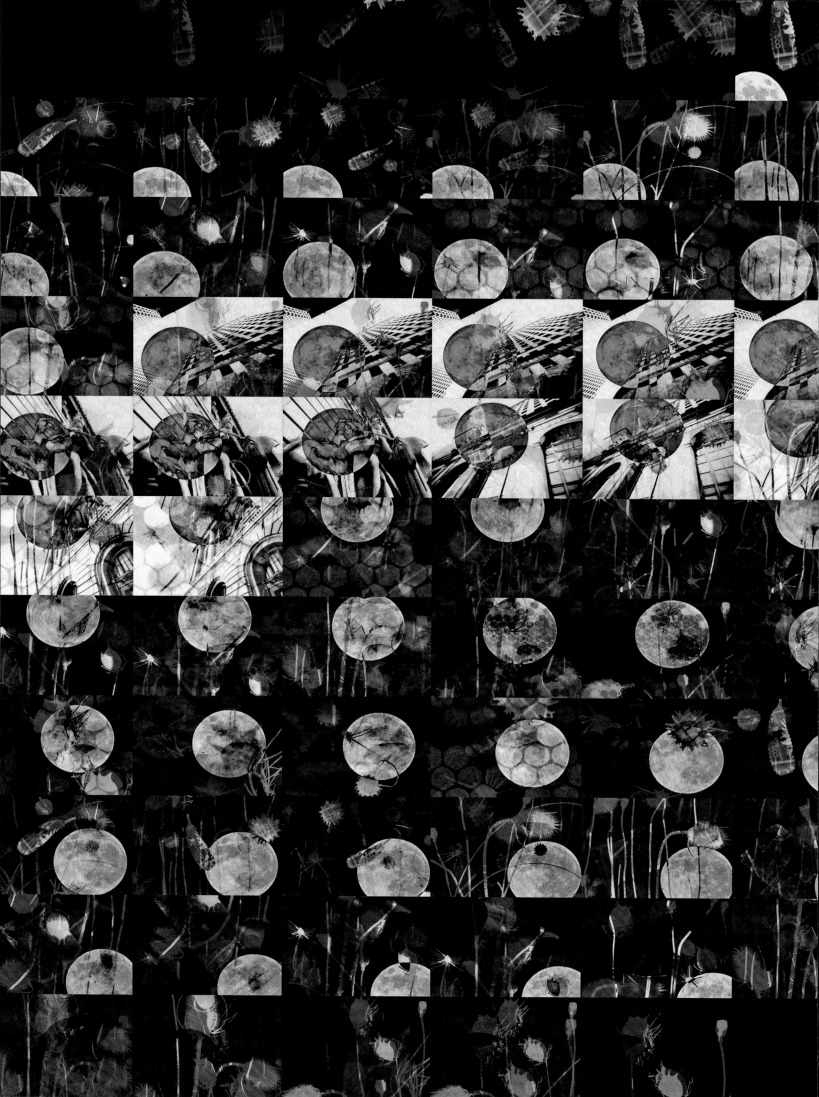

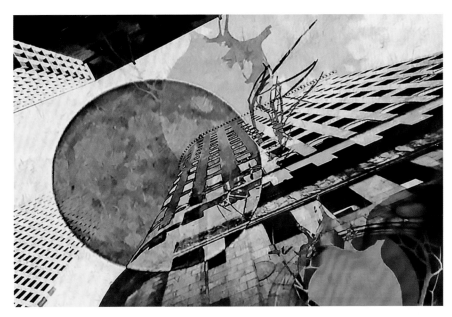

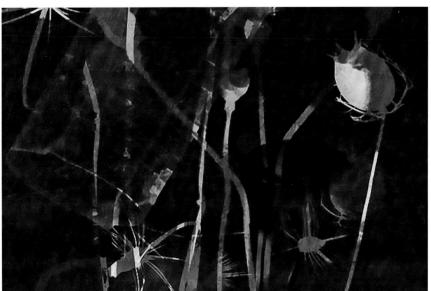

Meg Dreyer
Photo/Video Graphics, 2007
Untitled (3'08")

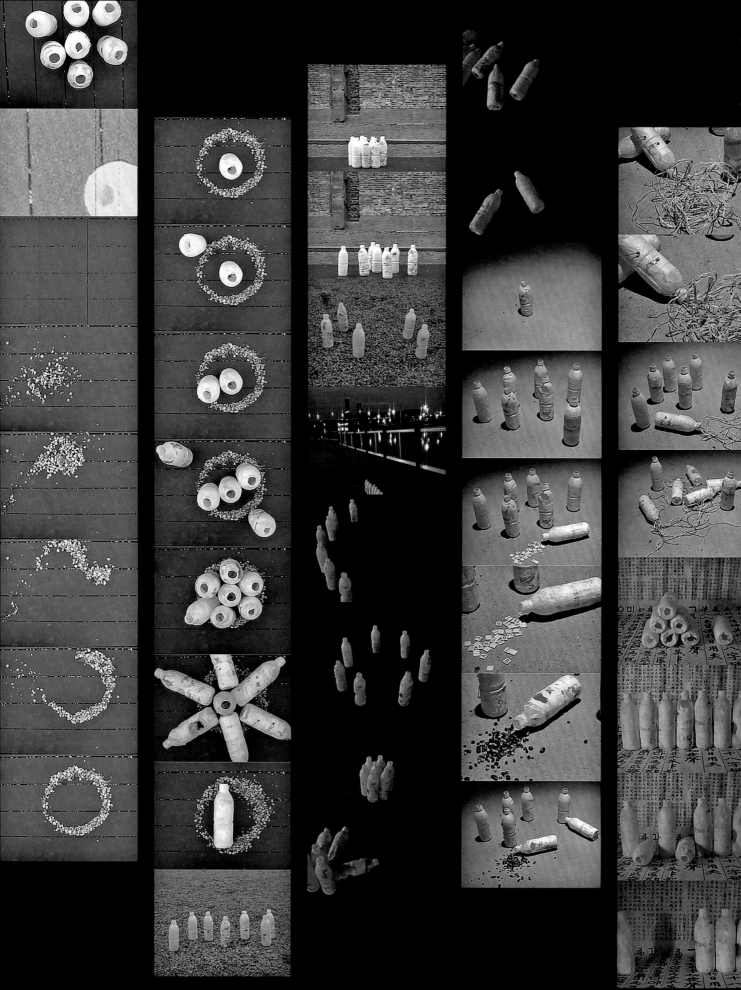

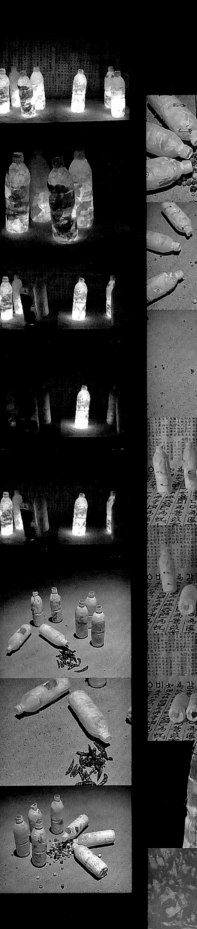

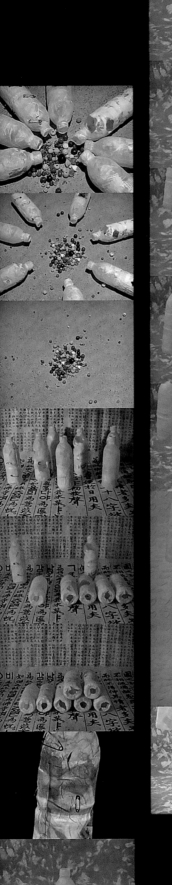

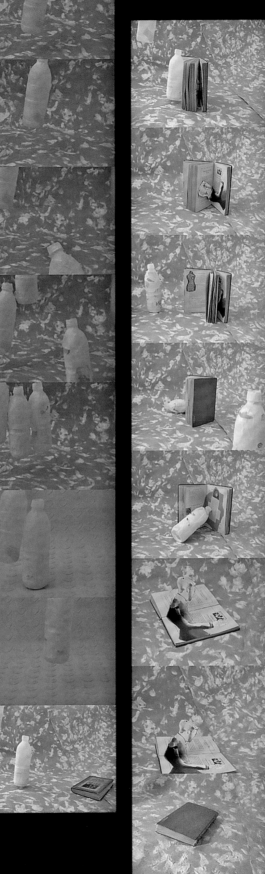

Jihye Shin
Music Video, 2007
Asceticism (1'57")

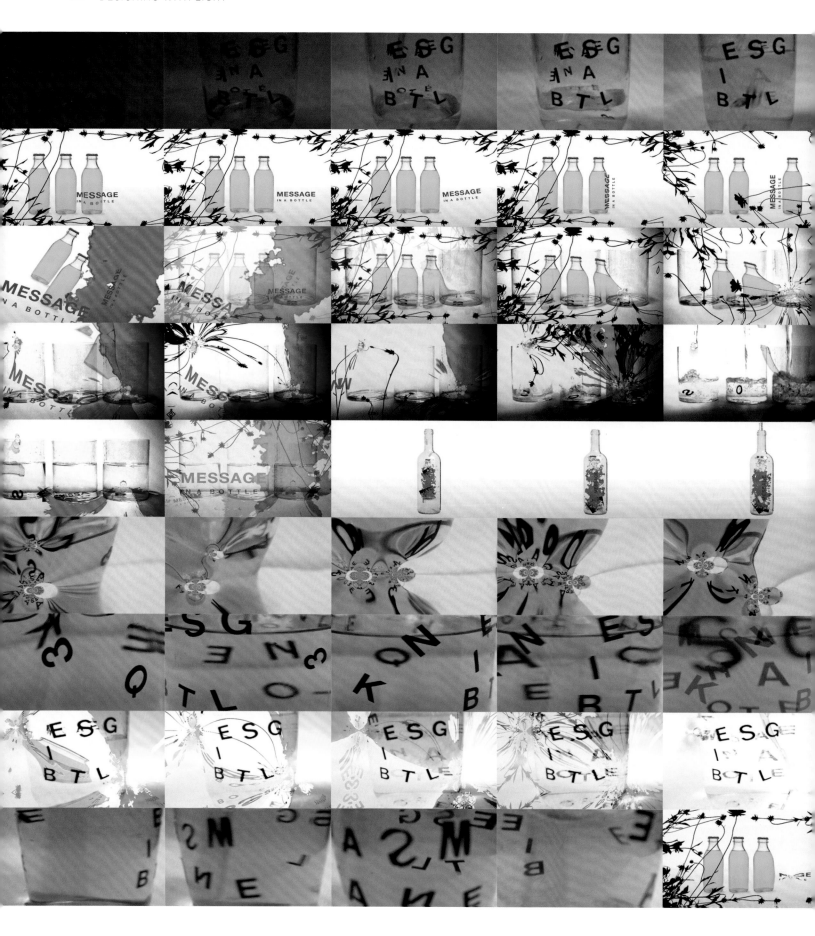

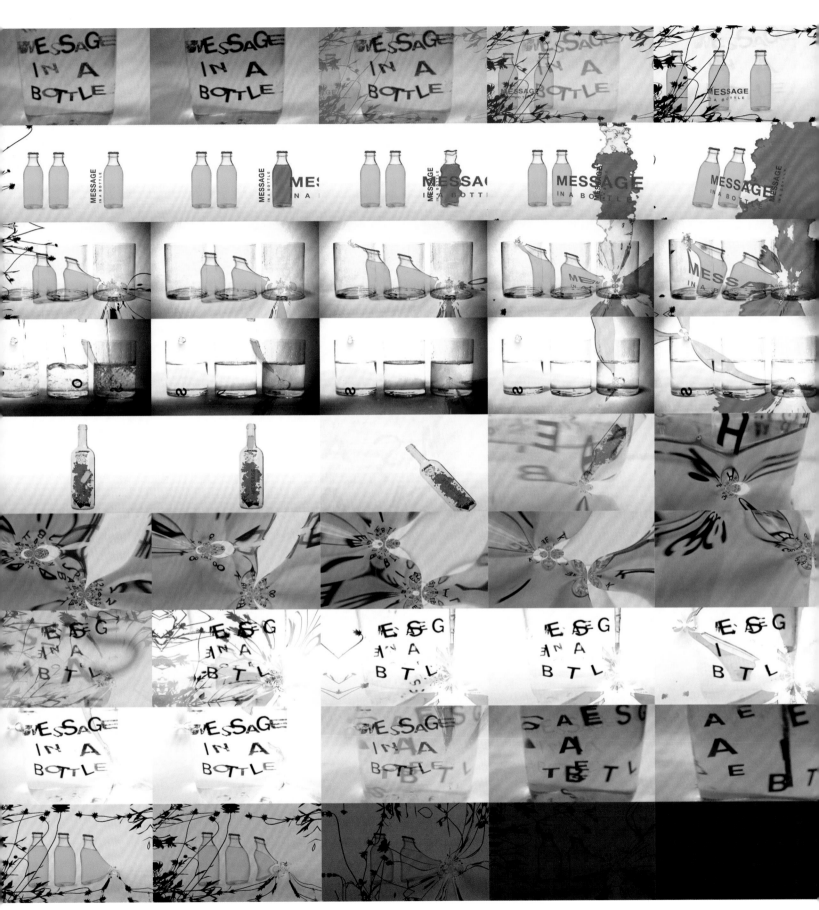

Ian Cox
Music Video, 2008
Message in a Bottle (2'58")

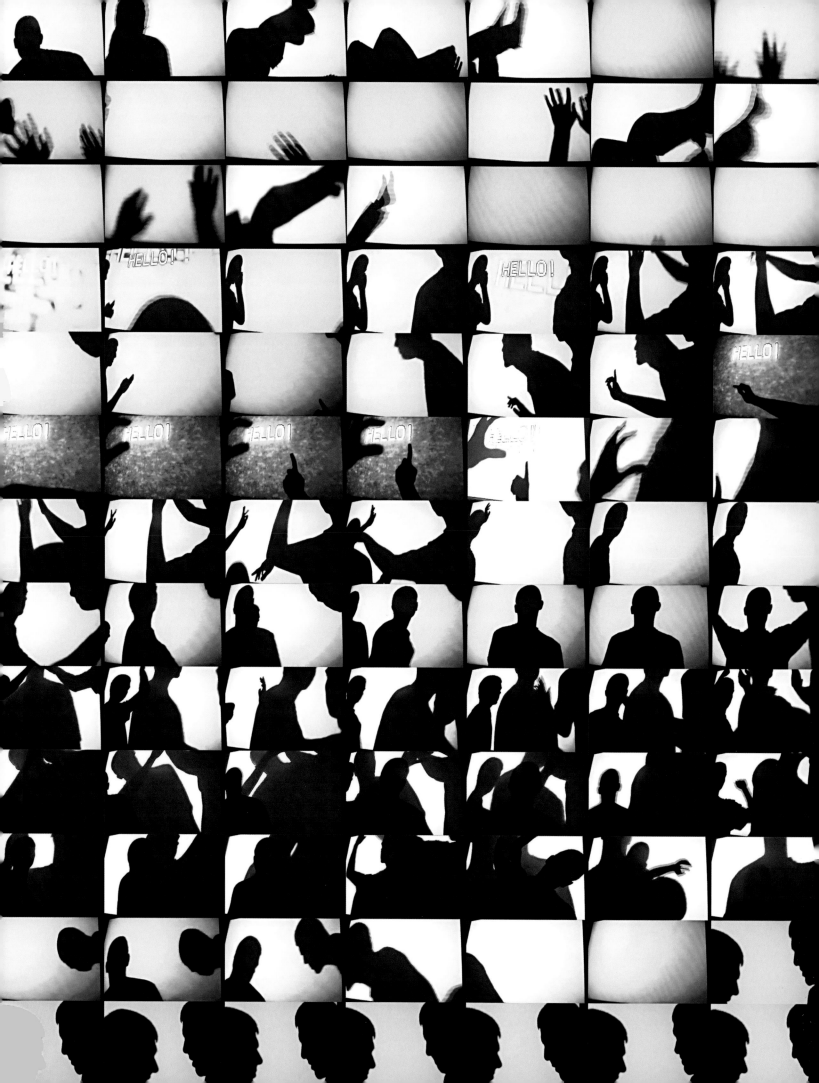

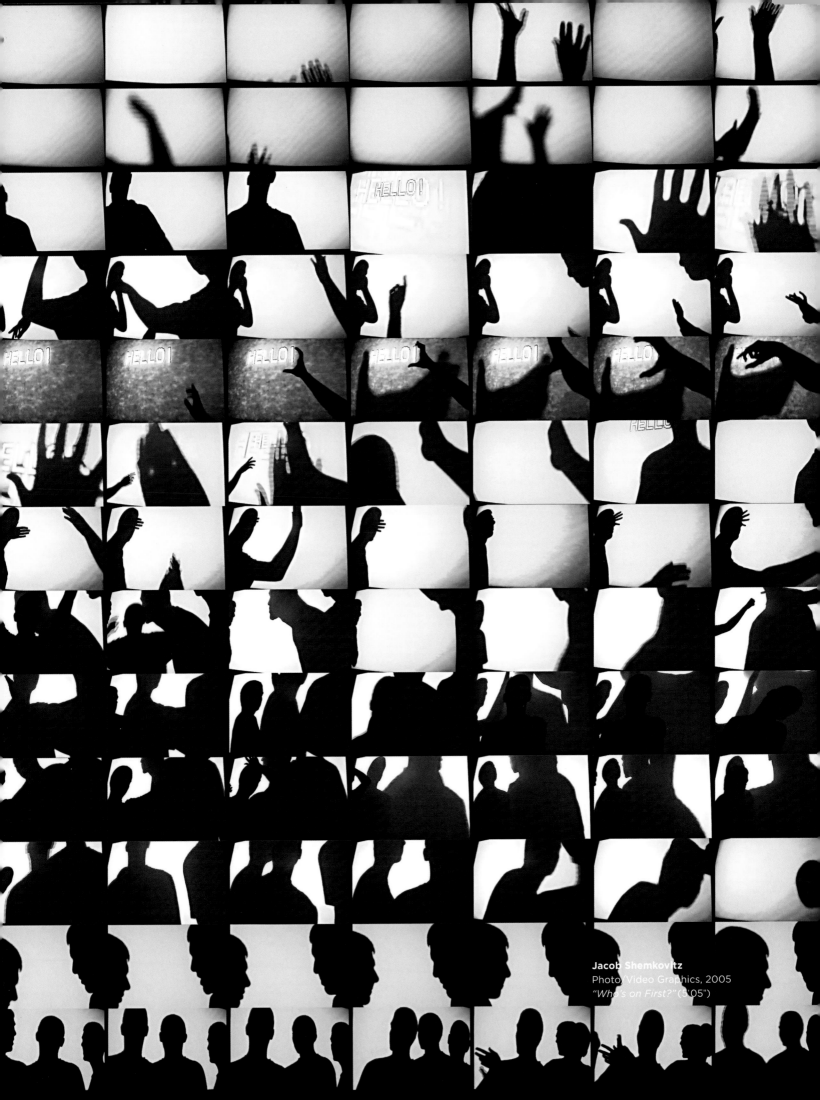

Jacob Shemkovitz
Photo/Video Graphics, 2005
"Who's on First?" (5'05")

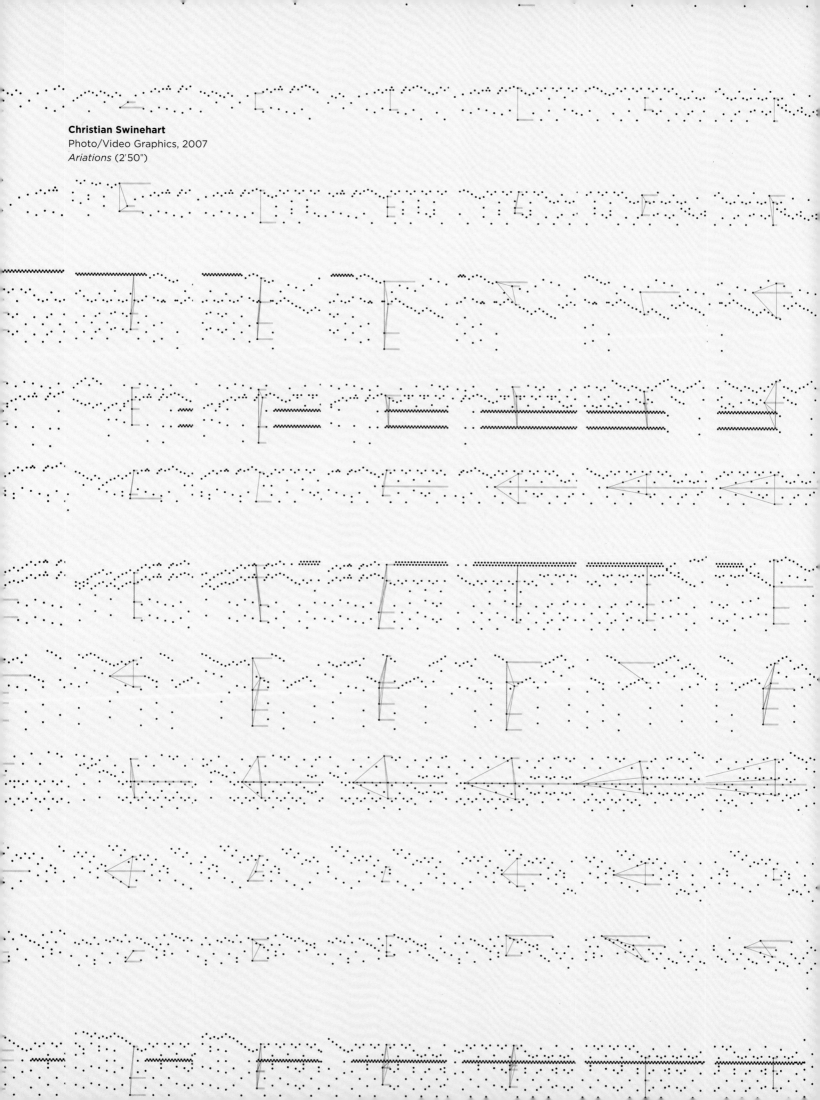

Christian Swinehart
Photo/Video Graphics, 2007
Ariations (2'50")

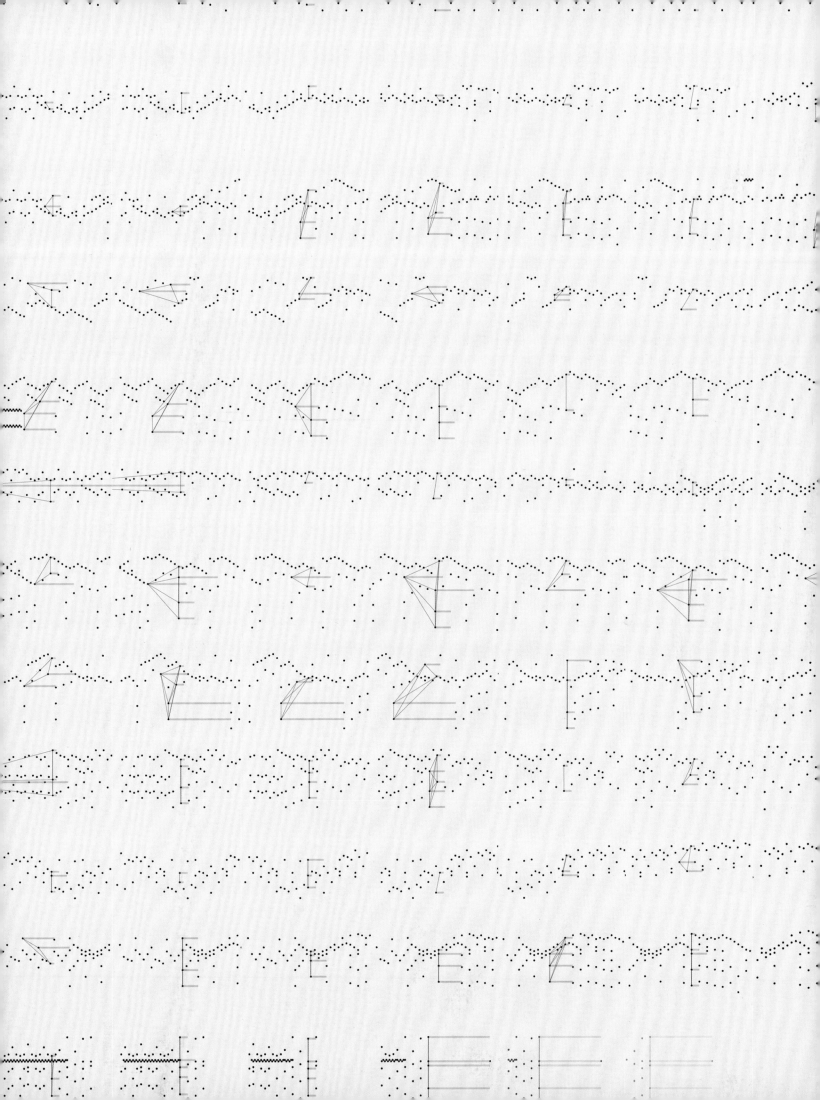

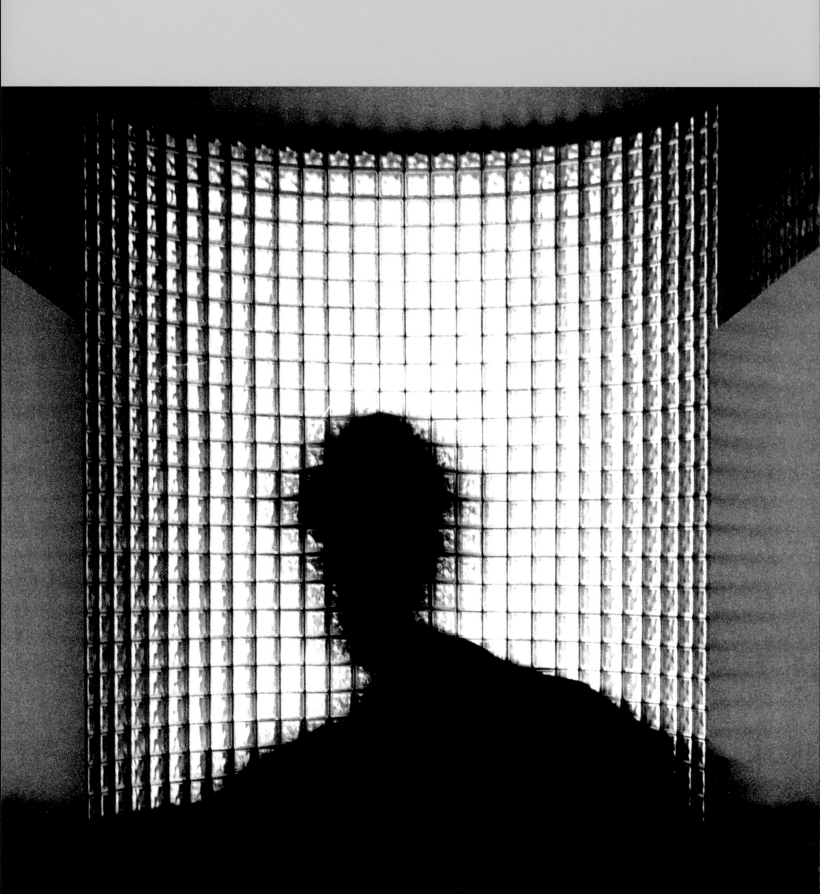

EPILOGUE

Like many photographers and artists of my generation, my work gradually evolved. There were many events and experiences in my life that influenced my choice of career and had a profound influence on my professional activities.

During my freshman year, photography was not part of the curriculum. However, the conviction still grew in me that I should become a photographer. I ventured into a photographer's studio for an internship. Shortly thereafter, I was diagnosed with congenital red-green color blindness and advised to refrain from studying photography. With no regrets, I chose the profession of a typographer, which I had studied at the School of Design in Basel, Switzerland, in 1972.

My autodidactic photographic career began with my first trip to North America at the age of 22. I traveled with a 35mm Mamiya/Sekor camera, and I shot mostly Kodachrome. During those six months of travel my handheld partner and I covered a diverse palette of landscapes. I began the journey in Montreal, Canada, in June 1973, and then continued from Alaska to Mexico and all the way to the Amazon in South America. My primary occupation was to photographically document every new discovery that each day offered.

The Mamiya camera was simple and easy to handle for a beginner like me. The bigger challenge was to cope with the constant agony of not knowing whether the pictures turned out successfully.

After this journey, my camera became my constant companion. It was not uncommon to share these photographic expeditions with my circle of friends. We spent many weekends shooting black and white film in a variety of settings, ranging from demolition derbies and construction sites to Roman ruins.

In 1975, during a stopover in Singapore, I was unable to resist the bargain prices for cameras and bought a Nikon F2. Not only was it a tool, but it was also a status symbol. But for me, its most important purpose was its ability to document and allow me to share my new life experiences with my family and friends in Switzerland.

The Nikon F2 turned out to be an excellent camera. With a shutter speed of a 1/2000th second and a Nikkor 50mm f/1.4 lens, I was in heaven.

When I returned to Basel, Switzerland, for graduate school in 1978, I attended photography classes for the first time. With the help of my photography teacher Max Mathys, who had good connections with the Leica camera manufacturer, I was able to afford a Leica R3. This camera was an essential tool and an integral interface to all the other media I used. The Leica lens Summicron-R

was of superb quality, which was especially notice-noticeable when compared to my earlier photo-graphs. In many of my classes, photography was an important medium. Due to the excellent photo facilities and its supporting instructors, the students frequented the photography department very often. The largest and most complex photo-graphic project I ever created began very humbly in professor Armin Hofmann's class. It was com-completed years later here in the United States and earned third place in the Photo District News/Nikon awards (pg. 133). Another tremen-dously influential experience in my artistic development was a film class that I took with the professors Peter von Arx and Peter Olpe. In fact, the studio photography class I teach today is rooted in the pedagogy of my friend and professor, Peter Olpe. Thanks to my professors at the School of Design in Basel, these three years of graduate studies were an important turning point in my creative life.

My teaching career began in 1981 at the Rhode Island School of Design. The Graphic Design Department had just installed a darkroom and required the sophomores to take an introduction to photography class. In addition to my aca-demic obligations, I also had the honor of meeting the iconic American photographer Aaron Siskind. There was a wonderful aura of great artistic inspi-ration surrounding RISD and Providence. In 1984, Friederich St. Florian, RISD's vice president, commissioned me to design the biennial faculty catalog. I took advantage of this opportunity to use my photographic skills in designing the catalog cover (see page 140). This project earned me recognition as far away as Brno, Czechoslovakia, at the international biennial of graphic design.

Though commercial aspects of photography never appealed to me much, teaching was the perfect place for me to share my professional expe-riences with the students and is a great source of inspiration for my own work. It is this spirit of exploration and visual discourse that I try to ignite in my students' minds.

This poster is a culmination in many aspects. The seed of this project was planted in my class with professor Armin Hofmann, and it began with the concept: "Window frames and their identity in or out of context."

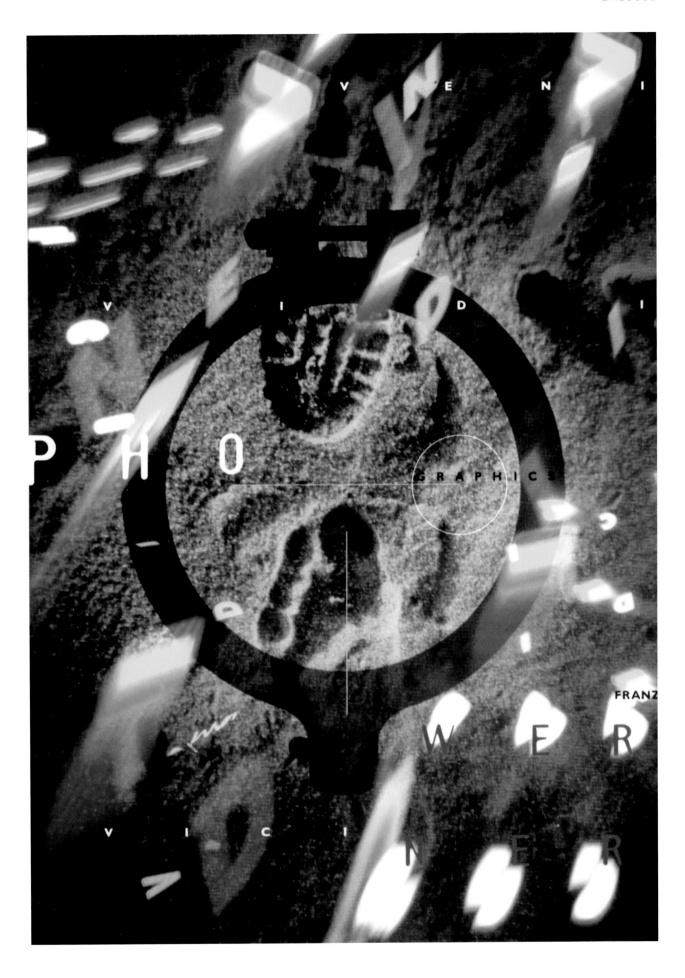

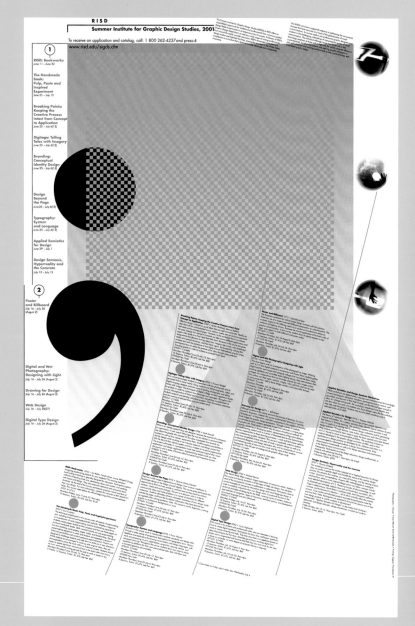

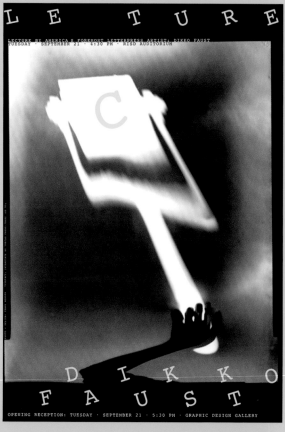

OPPOSITE
RISD Biennial 1995
Poster, 1995
Work for RISD

SIGDS
Poster, 2001
Work for RISD, Continuing Education

Dikko Faust
Poster, 1999
Work for RISD
Graphic Design Department

The poster on the opposite page was a collaboration with the graduate student Stephane Huot. I chose a pair of scissors, since it is a widespread tool used in all of the art and design disciplines taught at RISD. The typography in all three posters is strongly animated, and there is an active dialogue between type and image.

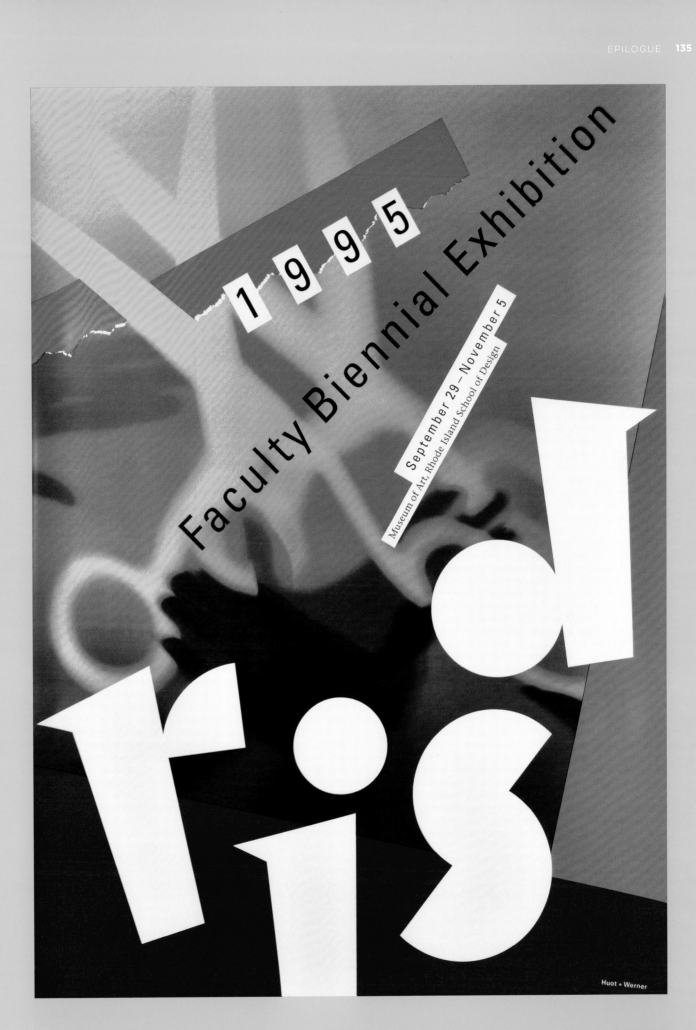

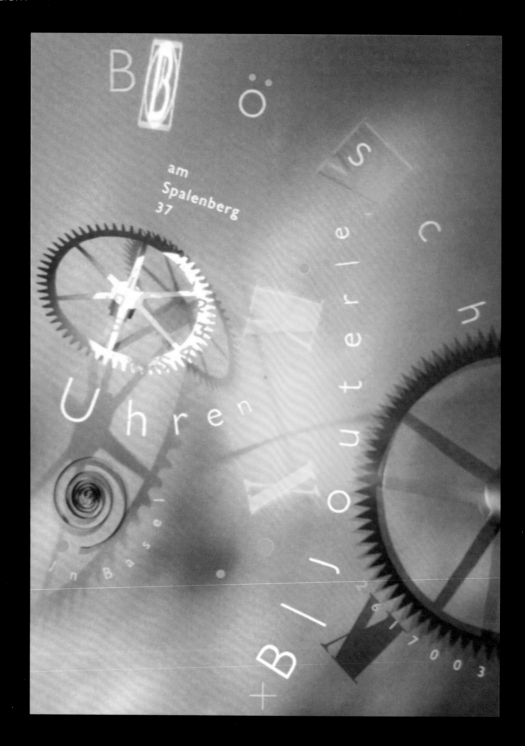

This project was another collaboration between graphic designer Jean-Benoit Levy and me. The client, a longtime friend, is a watchmaker by trade, but also manages his jewelry and watch store. Because the poster is a common vehicle for advertisement in Switzerland, I suggested to my friend that he try it to promote his business. Jean-Benoit and I agreed that I would be the image-maker and he would be the typographer and production director, since I lived in the U.S. and he lived in Switzerland, where the posters were going to be printed.

Using a vertical setup, I began to sketch. The clock pieces my client had given me were too small to work with, so I decided to have larger gears manufactured for the project. I reused old props as temporary stand-ins during the sketching process so that I could begin to observe how I wanted to use light. The vertical setting consisted of three layers. The bottom layer was a white sheet of paper with a lamp sitting on it. The next layer was a sheet of glass with frosted Mylar and Roman numeral cutouts laying on it. The top layer was another sheet of glass with more objects placed on it.

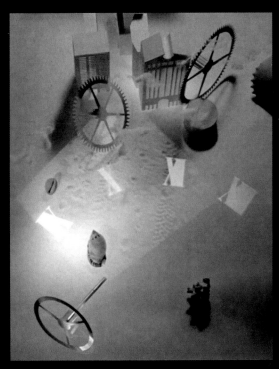

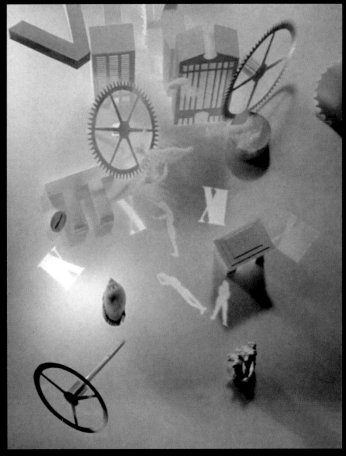

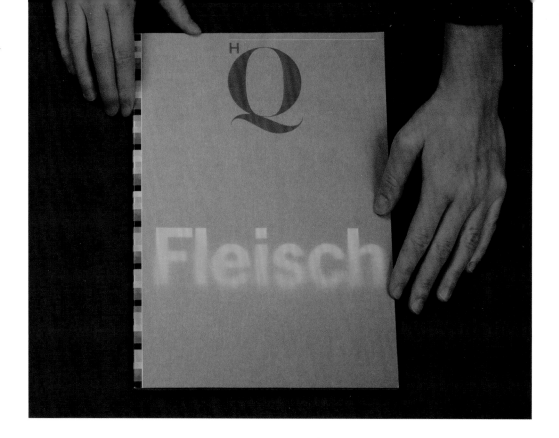

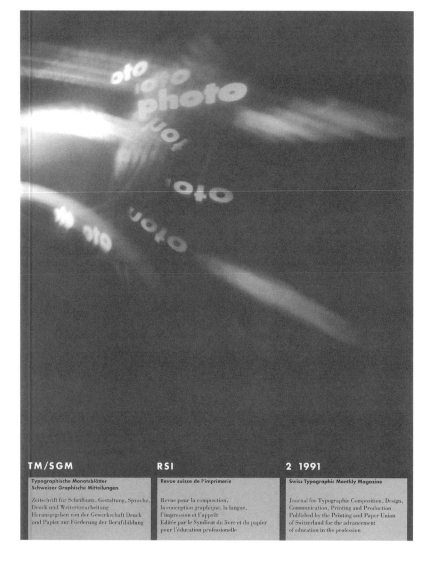

By projecting the word "photo" through a glass prism, I was able to create a fragmented image of the word in the spirit of its Greek meaning: light.

The editor Rolf Müller of *HQ* (High Quality) magazine commissioned me
to produce a series of sensual images to be used in their issue "Flesh"
for the theatre piece *The Confession of a Prostitute*, written by Claus Urban.

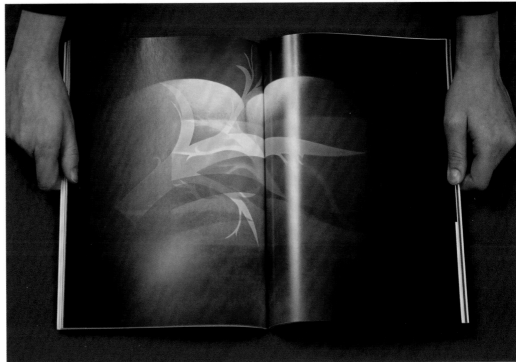

This piece was an exhibition catalog for the Rhode Island School of Design's Faculty Biennial. I chose an analytical, diagrammatic representation for the process of teaching art and design.

OPPOSITE
Props sitting on top of broken glass that I carefully arranged. I projected a local art deco building to add to the confusion. Also one might notice the Sony Tower, formerly the AT&T landmark in New York City, designed by Philip Johnson.

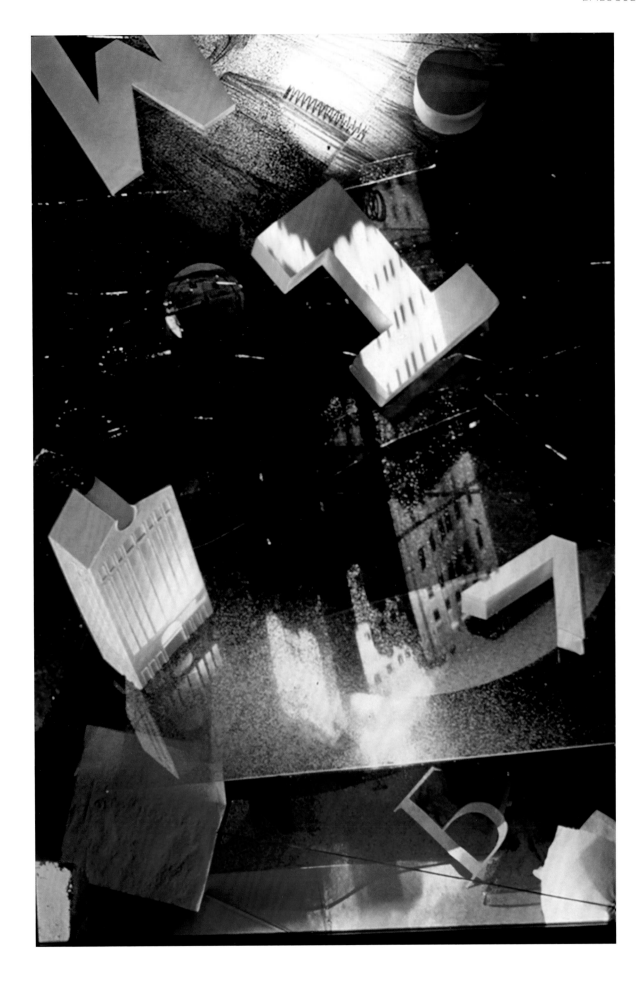

To all the backers of my Kickstarter campaign, I would like to express gratitude and appreciation. Your support and your generosity mean a lot to me.

A
Adleta, Don
Alexander, Dean
Alferdpacker
Anderson, Spenser
Aparicio, Ernesto
Arent, Michael + Jacqueline

B
Baker, Jan
Bardt, Christopher
Baum, Faith
Berbic, Amir
Bevington, Mark
Bottome, Bettina
breencf@gmail.com
Brink, Marisa Ten
Broennimann, Rolf
Brown, Wayne
Burbach, Frederick Jon
Burke, Lyndsey
Burton, Philip C.
Byrne, Mairead

C
Campbell, George
Childers, Patricia
Choi, Kelly Moonkyung
Chun, Cheah Wei
Colvin, David
Craig-Teerlink, Jean
Caserta, John
Corey, Jonathan

D
Dalmia, Sukeshi
Davidian, Katy
Davidson, Craig
Davis, Ruth
Dean Dixon, Keetra
dfrazer@risd.edu
Dornberger, Elmar
Duarte, Eduardo Benamor
Dumas-Hernandez, Amanda

E
elizabethkanderson@gmail.com
Eppelheimer, Michael
Evans, Barnaby

F
Fajardo, Rafael
Farley, Ryan
Fidler, Jennifer M.
Filion, Benoit
Fionte, Dan
Fleet Library at the Rhode Island
School of Design
Fong, Becky
Freedman, Peter
Fried, Geoffry
Friedman, Lee
Fulbrook, Conrad

G
Gaidula, Danniel
Goggin, James
Gokl, Renate
Goldstein, Mitch
Goodison, Richard
Gorkin, Baruch
Gregorian, Janette

H
Hahn, Suehee
Halladay, Devin
Hallgren, Thomas
Hay, Marjorie
Hayman, Pamela
Hennessy, Tricia
henry@horenstein.com
Hernandez, Ingrid
Herstowski, Andrea
Highsmith, Cyrus
Hirt, Ben
Hirt, Silvie
Hoff, Jessica
Horne, Brockett
Howard-Sheridan, Lorena
Huang, Cavan
Huang, Jeffrey

I
Inyoung Choi, Albert
Isserlis, Janet

J
Jang, Ashley
jbarnes@risd.edu
Johnson, Alexander

K
Kaliontzis, Joanne
Kallish, Adam
Kam, Curtis
Kanayama, Tohru
Kane, John
Kanorr, Allen
Katz, Jeffrey
Kim, Hyunmee
Kim, Soo Jin
Kim, Yoonkyung
Kitz, Keith
Koizumi, Hitoshi
Kopec, Walter and Sarah
Kraft, Daniel
Krooss Vyff, Marnie

L
Labb, Alan
LaGue, Ruth
Laughlin, Mark
Lawrence, Albert
Lawrence, Paul
Leahy, Patrick M
Lee Stack, Karen

Lenk, Krzysztof
Leu, Daniel
Levy, Jean-Benoit
Long, Bobbi
López, Juan Ramón
Low, Ashley

M
MacIlwraith-Wagner, Dannell
Maione, Lisa J.
Mastrianni, Gregory
mberger@risd.edu
Mcdonald, Angus L.
McDonald, Steven
McGinnis, Kevin
McLaughlin, Joy
McNiff, EJ
mdong@alumni.risd.edu
Mendonca, Duarte
Messier, Nicole
Monteza, Yolanda
Moyer, Don
Mrowczyk, Jacek

N
Nackaerts, Axel
Nadeau-Rifkind, Tim
Nelson, Guy-Jeff
Nurosi, Aki

O
Ockerse, Tom
Oh, Joo
ojy377@gmail.com
Olpe, Peter
Osso-Werner, Charlotte

P
Paradiso, Michael A.
Park, Hyejung
Park, Hyoshin
Park, Young Won
Peters, Ronnie
Pettis, Valerie
PhotoShelter
Popova, Katya
Post, Soe Lin

R
Ramos, David
Reiser, Hans-Ueli
Riley, Michael
Ring, Kevin
Roach Cline, Brittney
Roberts, Chris
Rolfsema, Jennifer
Rosenbloom, Mindy

S
Saigal, Siddharath
Salvadore, Anne
Salvadore Goodison, Mary
Sappa, Adrienne

Schneider Hammarberg, Jill
Schuetz-Domer, Andre
& Jennifer
Schwartz, Jonathan
Scott, Douglass
Seo, Hyojung
Sherif, Francisca
Siriwangsanti, Siriporn
Skolos-Wedell
Small Stuff
Smith, Karen Dendy
Soler-Roig, Miguel
Sorensen, Gerta
Soulellis, Paul
Sparrgrove, David
Stachel, Aernscht and Blanka
St.Cyr, Chris
Stephens, Kirby
Stowell, Scott
Strickland, Anna

T
Tantivejakul, Kanit
Tarallo, Donald
Terry, John
Tucker, Carlton

V
Vanegas, Roy
Viemeister, Ian
Villari, Evan
visualarchitect@hotmail.com
Voccola, Barbara

W
Werner, Adrian
wghory@aol.com
Wilentz, Kathleen
Winkler, Dietmar R.
Wyatt, Robert

Y
Yazici, Atilla

Z
Zelman, Stephanie
Zoels, Jan-Christoph

Acknowledgments

It is with great honor and with immense gratitude that I would like to mention the kindness and the support of the people who were involved in making this book possible. In the year 2000, during my term as head of the graphic design department, I realized that there was a need to archive student work in a digital format. We began scanning photos for a long time until digital cameras made it obsolete. The idea of documenting student work never left my mind and it started to haunt me. Nine years later, during a half-year sabbatical, I decided to make a decision on the future of documenting student work. I was determined to author and to publish a book with work of my students. Due to the overwhelming volume of student projects, I decided to narrow it down to an area of specificity. Focusing on the history of graphic design education, I recognized that pho-photography had always been an integral medium belonging to the core principles of graphic design. I have been teaching photography in the graphic design department since the late '80s in the following classes: Photo/Graphics, Form and Communication, Type and Image in Motion, and Music Video. The cataloguing of the hundreds of students and their projects became a challenging task. With that in mind, the next challenge I was confronted by was the editing of the many choices of student work. I was in need of help. I hired Hannah Kim, who had graduated from graphic design at RISD, to help me on the layout for the prototype publication under my art direction. Hannah also created the beautiful drawings that describe the different techniques. Since English is not my mother tongue, I contracted Millee Tibbs, who is a former graduate student from RISD's photo department, to edit my text. At the end of my sabbatical, we were the proud bearers of a 300+ page prototype. My colleague Ernesto Aparicio, whom I hired to teach in our department, became an inspiring supporter of my project, and he persuaded me to join him to attend the book fair in Frankfurt, Germany. My book as a prototype was reviewed at the prestigious Frankfurt Book Fair and included meetings with representatives from several publishers, whose reactions were positive, and they gave serious consideration to the prototype. There was only one caveat: printing this book would not be profitable. Some instructed me to make certain concessions, which would have turned this valuable document into a trade art book. I was not swayed by these arguments. Rather than pursuing other options, I have chosen self-publishing as the answer. I decided to use a crowd-funding project, which will allow me to independently print and bind this book. For my Kickstarter campaign, I was very fortunate to recruit an incredibly talented team: Ben Hirt, FAV/RISD 2010, who shot and edited an expert pitch video for the Kickstarter; Brittany Huang, graphic design junior, who became an indispensable help and without whom I might have not reached the goal; Pablo Gutierrez-Gladwish, graphic design senior, who designed the website designingwithlight.net.

In order to make the book affordable, I decided that the existing 300+ page prototype needed to be reduced in size, and used as a guide for the modified layout version. I chose Ernesto to be the design editor for this task. He also introduced me to printing agents Kathy Rosenbloom, Alberto Gibellini, and Enrico Bighin of Elcograf printing in Verona, Italy, where *Designing with Light* was printed and bound. Congratulations to all the people from Elcograf; their commitment and their craftsmanship are exceptional. Thank you to the fantastic team of proofreaders: Frances Shipps, Monica Allard Cox, and Adrian Werner.

Last but not least, I would like to express my gratitude to my spouse Charlotte Osso-Werner and my son Adrian Werner for their encouragement and their kindness in supporting this project.

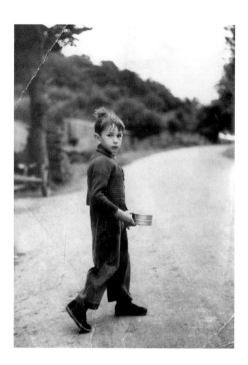

Published with the generous support of backers of the Kickstarter campaign, partial funding by the faculty professional development grant of the Rhode Island School of Design and by RISD's Division of Architecture and Design.

OPENING CHAPTERS PHOTO CREDITS:

Page 8:
Maggie Putnam, *Form and Communication*, 2006

Page 26:
Dave Brooks, *Photo/Graphics*, 1994

Page 46:
Dave Brooks, *Photo/Graphics*, 1994

Page 64:
Kristen Biddison, *Form and Communication*, 2000s

Page 92:
Hannah Kim, *Form and Communication*, 2006

Page 130:
Franz Werner

Support staff of Kickstarter crowdfunding campaign:

Ben Hirt, RISD BFA, 2010, videographer/editor
Brittany Huang, RISD, 2019, campaign assistant
Pablo Gutierrez-Gladwish, RISD, 2018, web designer

Book Design:

Prototype: Hannah Kim, RISD BFA, 2009, Franz Werner
Ernesto Aparicio, design editor
Book Jacket photograph: Franz Werner

Text:

Franz Werner, author
Millee Tibbs, RISD MFA, 2007, editor

Proofreading:

Frances Shipps, Monica Allard Cox, Adrian Werner

Typefaces:

Gotham by Tobias Frere-Jones, RISD BFA, 1992
Prensa by Cyrus Highsmith, RISD BFA, 1997

Printed and bound in Italy:
Elcograf, Verona

imvdesign.com

ISBN 978-1-5323-7181-3